HOW TO DRAW
chibi

Text and Layout:
Rod Espinosa, Robert Acosta

Cover:
David Hutchison

Art Contributions:
Ben Dunn, David Hutchison,
Joseph Wight, John Kantz

Editing:
Robert Acosta
Doug Dlin

HOW TO DRAW chibi

Graphic Designer - Robert Acosta
Cover Design - David Hutchison & GURU-eFX
Layout - Doug Dlin

Editor in Chief - Jochen Weltjens
President of Sales and Marketing - Lee Duhig
Art Direction - GURU-eFX
VP of Production - Wes Hartman
Publishing Manager - Robby Bevard
Publisher - Joe Dunn
Founder - Ben Dunn

Come visit us online at www.antarctic-press.com

How to Draw Chibi Pocket Manga Vol. 1
An Antarctic Press Pocket Manga

Antarctic Press
7272 Wurzbach Suite 204 San Antonio, TX 78240

Reprints material from *How to Draw Chibi Supersize* TPB Vol. 1
First published in 2005 by Antarctic Press.

ISBN: 978-0-9816647-0-5
Printed and bound in Canada.

VOLUME 1

HOW TO DRAW chibi™

TABLE OF CONTENTS

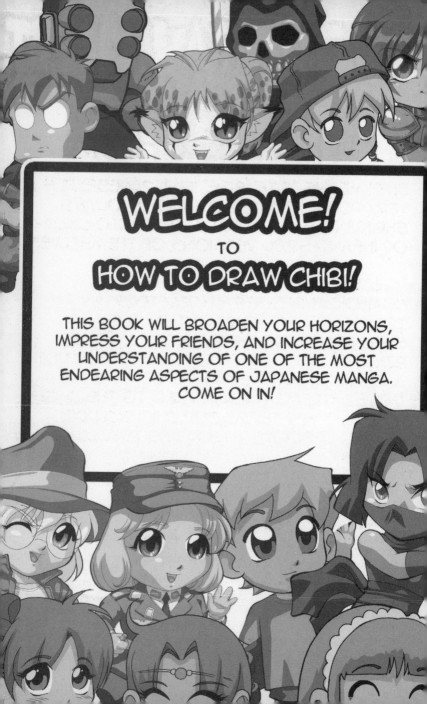

HOW TO DRAW CHIBI

WHAT IS CHIBI?

CHIBI MEANS "BITE-SIZE" IN JAPANESE. IT'S A VERY POPULAR ART TECHNIQUE INVOLVING SHRINKING MANGA CHARACTERS INTO CHILD- OR INFANT-SIZED VERSIONS OF THEMSELVES.

"CHIBIFICATION" IS OFTEN DONE FOR COMEDIC PURPOSES. CHARACTERS TRANSFORM INTO AND OUT OF THIS SHRUNKEN MODE THROUGHOUT A COMIC BOOK STORY. MANGA EXPRESSIONS, WHILE ALREADY MOSTLY EXTREME, BECOME EVEN MORE EXTREME WHEN APPLIED TO THE CHIBI REALM. OTHER TERMS FOR CHIBI INCLUDE "SUPER-DEFORMED" (SD) AND "SMALL-BODIED."

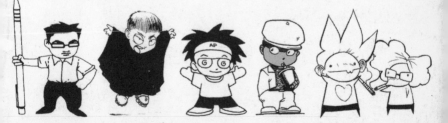

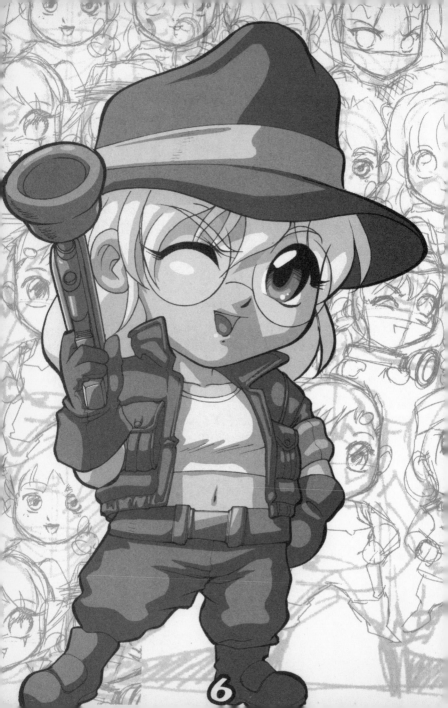

CHAPTER
1
INTRODUCTION

MATERIALS
YOU NEED
TO DRAW!

PAPER

SHOWN HERE IS AN EXAMPLE OF "TYPE A" MANGA ART PAPER. PRINTED ON IT ARE A BUNCH OF LINES AND MEASURE- MENTS THAT DON'T MAKE MUCH SENSE TO SOME PEOPLE.

IN THE FOLLOWING PAGES, WE WILL HELP YOU UNDERSTAND THESE MARKINGS.

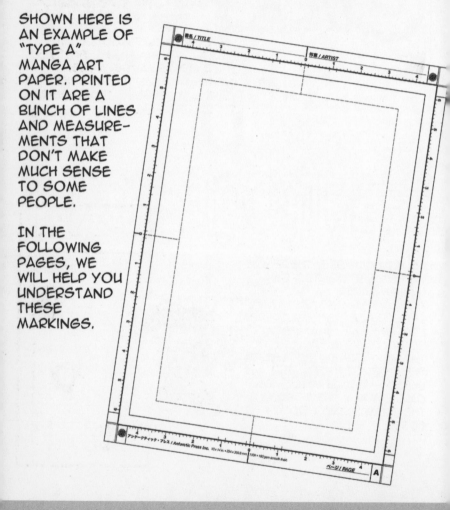

HOW TO DRAW CHIBI

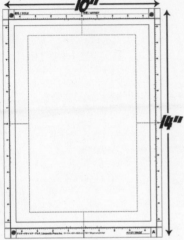

PAPER SPECS

UNLIKE REGULAR BRISTOL ART BOARD, MANGA PAPER ISN'T AS THICK OR AS LARGE. AT TEN INCHES BY FOURTEEN INCHES, IT'S JUST A BIT BIGGER THAN REGULAR TYPEWRITING PAPER.

AS YOU CAN SEE, THERE ARE THREE LINES PRINTED ON MANGA PAPER.
THE DOTTED LINE TO THE INSIDE (3) IS CALLED THE "LIVE AREA". IT'S THE MAIN SPACE FOR YOUR ILLUSTRATION.
THE NEXT (2) IS FOR "THE CUT."
THE THIRD (1) IS FOR THE BLEED-- THAT'S WHAT YOU CALL IT WHEN THE EDGES OF THE DRAWING RUN OFF THE EDGE OF THE PAPER.

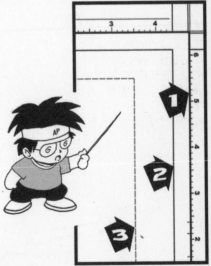

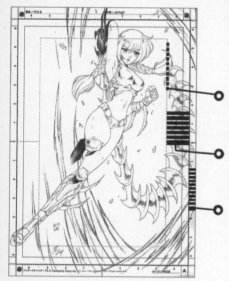

Main image area. Your drawing is safe from cropping inside this area.

Cut Area. Your artwork may be cut off at around this zone.

Bleed. Artwork will definitely be cut off in this area.

WHEN YOU DON'T USE THE GUIDELINES THE RIGHT WAY, YOUR DRAWING MAY APPEAR TO BE FINE ON PAPER, BUT WHEN IT IS SENT TO BE PUBLISHED, MUCH OF YOUR ARTWORK WILL BE IN DANGER OF GETTING CUT AWAY.

THE DOTTED SQUARE IS WHERE MOST OF THE IMPORTANT STUFF SHOULD HAVE BEEN, LIKE MOST OF THE FIGURE AND ACTION. THE REST OF THE DRAWING SHOULD HAVE BLED OFF THE PAGE. HERE THE DRAWING IS CUT LIKE IT WOULD BE IF IT WERE PRINTED. A LOT OF STUFF GETS LOST AND MAKES THE PIECE LOOK BAD.

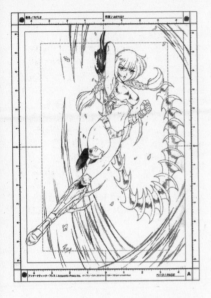

WHEN THE GUIDELINES ARE USED PROPERLY, THE DRAWING BECOMES CENTERED AND BALANCED.

BY KEEPING THE FOCUS OF THE ILLUSTRATION INSIDE THE "LIVE AREA" BOX WHEN THE DRAWING IS PRINTED AND CUT, THE INTENDED EDGES OF THE DRAWING END UP AT THE EDGES OF THE PAPER.

HOW TO DRAW CHIBI

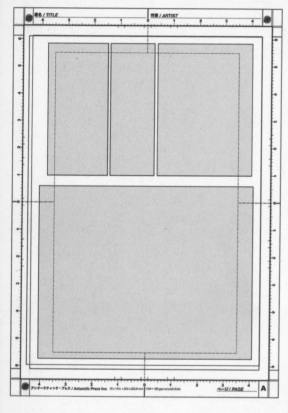

THE LAST THING ABOUT MANGA PAPER IS THE RULERS ALONG THE SIDES. THESE RULERS HELP YOU WHEN YOU'RE DIVIDING THE PAPER FOR YOUR PANELS. USE THE GUIDES TO PLACE A RULER AT EXACTLY THE SAME PLACE ON EITHER SIDE OF THE PAGE, THEN--VIOLA--PERFECT PANELS.

NOTICE HOW PANELS THAT ARE NEXT TO EACH OTHER HAVE A SMALLER SPACE (OFTEN CALLED A GUTTER) BETWEEN THEM THAN THE PANELS BELOW.

YOU MIGHT HAVE NOT NOTICED THEM BEFORE, AND THAT IS GOOD-- YOU AREN'T SUPPOSED TO. AS YOU READ A PAGE, YOUR BRAIN REGISTERS THESE SPACES AS PATHWAYS. YOUR BRAIN TELLS YOU TO READ THE PANELS CLOSER TOGETHER FIRST, THEN MOVE TO THE PANELS FURTHER AWAY.

GO THROUGH YOUR FAVORITE MANGA AND PAY CLOSE ATTENTION TO THE USE OF THE GUTTERS. IT WILL HELP YOU UNDERSTAND THE DIFFERENCE BETWEEN GOOD AND BAD STORYTELLING.

AN INTERESTING FACT IS THAT THE PANEL ARRANGEMENT SHOWN HERE WORKS IN THE JAPANESE RIGHT-TO-LEFT AND WESTERN LEFT-TO-RIGHT FORMATS. IN JAPAN, PANELS 4, 5, 6, AND 7 ARE READ BEFORE HEADING TO THE CLOSER 4-THROUGH-8 PATH. THIS REFLECTS THE WAY THE JAPANESE READ TOP TO BOTTOM. WESTERN COMIC ARTISTS STACK THEIR PANELS ALSO, ALTHOUGH NOT AS OFTEN AS THEIR JAPANESE COUNTERPARTS. BUT THE REAL DIFFICULTY THERE IS KEEPING THE STACKS ON THE RIGHT SIDE OF THE PAGE TO MAKE IT EASIER TO READ. STACKS ON THE LEFT SIDE IN WESTERN COMICS ARE DIFFICULT TO READ.

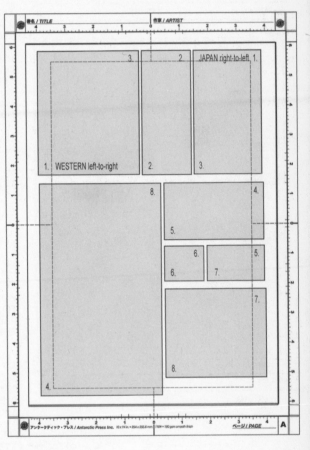

HOW TO DRAW CHIBI

HERE'S A SHORT RUNDOWN ON
DRAWING MATERIALS AND TIPS ON
HOW TO KEEP YOUR ARTWORK CLEAN.

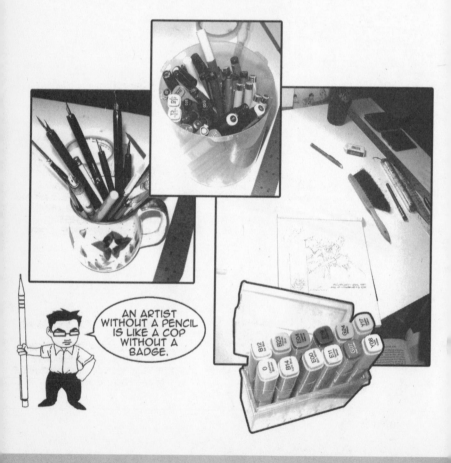

AN ARTIST
WITHOUT A PENCIL
IS LIKE A COP
WITHOUT A
BADGE.

DRAWING TOOLS

SKETCH PENCIL
WITH HB TYPE LEAD.
YOU CAN ALSO USE A BLUE
PENCIL FOR SKETCHING.

INK PENS.
WHETHER DISPOSABLE OR
REFILLABLE, DEPENDABLE INKING
PENS ARE A MUST FOR ANY
SERIOUS MANGA ARTIST.
GOOD BRANDS INCLUDE COPIC,
MICRON AND ZIG.

INK.
WHITE INK, USED FOR INKING IN
HIGHLIGHTS.
BLACK INK, USED WITH DIP PENS
AND BRUSHES. BRUSHES ARE
GOOD FOR RENDERING LINES OF
VARYING THICKNESS.

HOW TO DRAW CHIBI

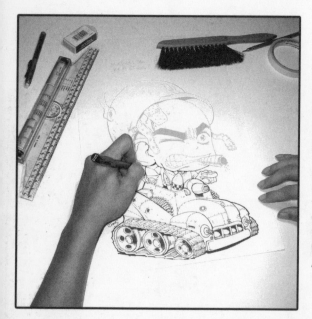

MOST OF THE INKING FOR THIS SERIES WAS ACCOMPLISHED WITH THE USE OF ZIG AND COPIC PENS. YOU CAN ALSO USE LARGE BLACK MARKERS TO FILL IN YOUR BLACK AREAS INSTEAD OF USING BRUSH AND INKS.

HOW TO DRAW CHIBI

RULERS AND CURVES

GOOD FOR DRAWING PERFECT LINES.

UHH... RIIIIIGHT...

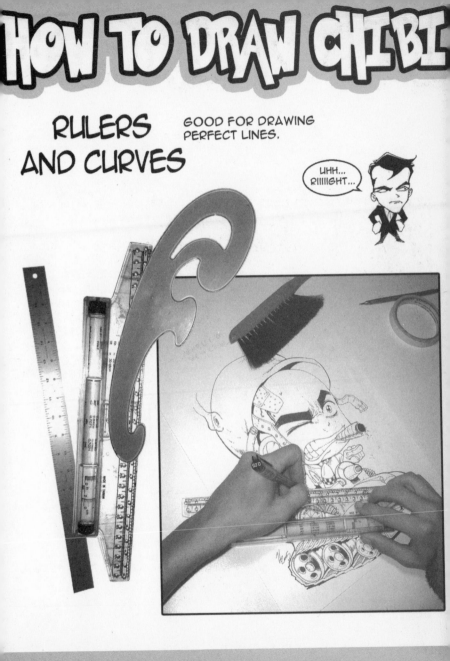

CORRECTION FLUID. SHOWN HERE IS A CORRECTION FLUID PEN. YOU CAN ALSO APPLY WHITE PAINT USING A BRUSH, IF YOU WANT. WHITE PAINTS DON'T HAVE THAT AWFUL ALCOHOL SMELL A LOT OF CORRECTION FLUIDS HAVE, AND IN MOST CASES ARE MORE OPAQUE.

PEN ERASER. USING A PEN ERASER IS HELPFUL WITH ERASING TINY SPOTS. YOU CAN ALSO USE AN ERASING SHIELD.

ERASER. BE SURE TO INVEST IN A GOOD ERASER. THE TYPICAL ONES THAT YOU CAN BUY AT ANY SCHOOL SUPPLY STORE MAY END UP RUINING YOUR WORK OR TEARING UP YOUR PAPER SURFACE, SO YOU WILL PROBABLY WANT A SOFT WHITE PLASTIC ERASER.

CLEANING BRUSH. NOT A NECESSITY, BUT USEFUL FOR WIPING OFF BITS OF DIRT LEFT BEHIND FROM ERASING. THIS ELIMINATES USING YOUR HAND TO BRUSH BITS FROM THE PAPER, WHICH MAY DAMAGE YOUR WORK.

CAREFUL!

MAKE SURE YOUR INK IS DRY WHEN YOU ERASE.

ALSO, BAD ERASERS CAN RUIN YOUR WORK BY SMEARING THE INK OR TEARING UP THE PAPER!

EEEK! WATCH IT!

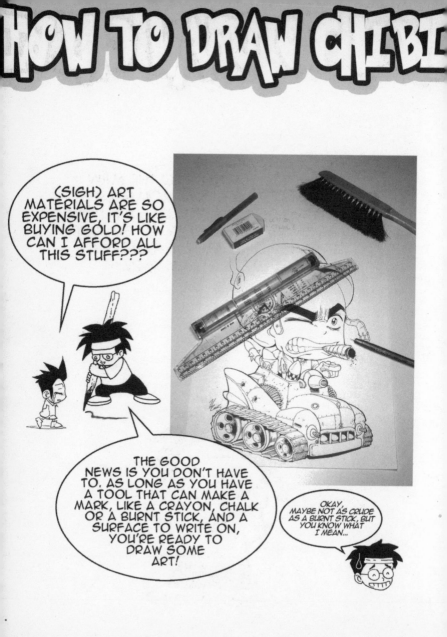

HOW TO DRAW CHIBI

ALL RIGHT!
LET'S PROCEED NOW TO THE MAIN
SECTION OF OUR BOOK! YOU BOUGHT
THIS TOME SO YOU COULD LEARN HOW
TO DRAW. THERE'S PLENTY OF GROUND
TO COVER SO TURN THE PAGE AND
LET'S DRAW SOME CHIBI!

22

CHAPTER 2

LET'S DRAW CHIBI!

BODY STRUCTURE AND BASIC PROPORTIONS

HOW TO DRAW CHIBI

"CHIBI" OR "SUPER-DEFORMED" IS USUALLY EMPLOYED TO CREATE AN INCREDIBLY CUTE CHARACTER OR EMPHASIZE AN EXPRESSION OR EMOTION. HERE ARE SOME BASIC PROPORTIONS FOR DRAWING "SMALL-BODIED" CHARACTERS:

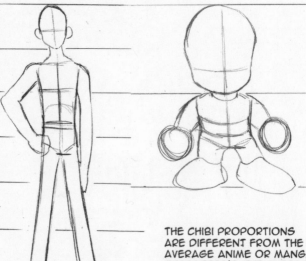

THE CHIBI PROPORTIONS ARE DIFFERENT FROM THE AVERAGE ANIME OR MANGA CHARACTER'S. THE AVERAGE CHARACTER IS ABOUT 6 1/2 TO 7 HEADS TALL.

THE AVERAGE SMALL-BODIED CHARACTER IS ABOUT 2 TO 3 HEADS TALL, WITH THE HEAD TAKING UP ONE THIRD OR HALF THE BODY SIZE!

ADULT MALE CHIBI

THE ADULT MALE BODY AND ITS CHIBI COUNTERPART. NOTE THE BROAD SHOULDERS OF THE FIGURE. THE SHAPE IS BOXY, AND ANGLES RATHER THAN CURVES ARE USED IN THE CONSTRUCTION OF THE BODY.

HOW TO DRAW CHIBI

YOUNG MALE CHIBI

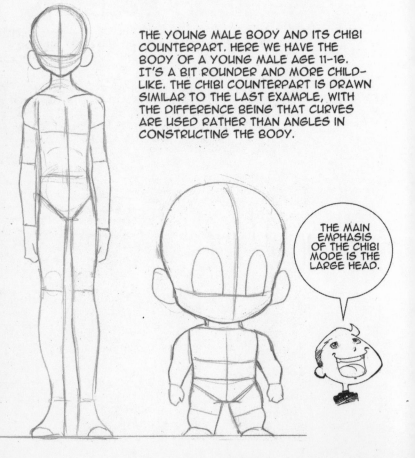

THE YOUNG MALE BODY AND ITS CHIBI COUNTERPART. HERE WE HAVE THE BODY OF A YOUNG MALE AGE 11-16. IT'S A BIT ROUNDER AND MORE CHILD-LIKE. THE CHIBI COUNTERPART IS DRAWN SIMILAR TO THE LAST EXAMPLE, WITH THE DIFFERENCE BEING THAT CURVES ARE USED RATHER THAN ANGLES IN CONSTRUCTING THE BODY.

THE MAIN EMPHASIS OF THE CHIBI MODE IS THE LARGE HEAD.

FEMALE CHIBI BODY

THERE ARE TWO TYPES OF FEMALE CHIBI, THE CHILD-LIKE FEMALE CHIBI AND THE SUPER-DEFORMED ADULT FEMALE BODY.

THE CHILD-LIKE FEMALE CHIBI IS PATTERNED AFTER THE SHAPE OF A TODDLER (WITH THE USUAL EXTRA-LARGE HEAD). THE SMALL-BODIED ADULT CHIBI HAS FEATURES SIMILAR TO ITS FULL-SIZED VERSION.

HOW TO DRAW CHIBI

1. HERE IS AN EXAMPLE OF THE FEMALE CHIBI WITH ADULT FEATURES.

2. SECOND IS THE MUSCULAR CHIBI USED TO CARTOONIZE MACHO MEN. YES, EVEN THE BURLY MAN HAS HIS CHIBI COUNTERPART. IN THIS CASE, THE BUILD IS MORE STOCKY AND MUSCULAR.

3. THIRD IS AN EXAMPLE OF THE CATCH-ALL MODEL FOR CHIBI. THIS ONE IS MORE SIMILAR TO A REALISTIC CHILD WITH CLEAR FEATURES LIKE HANDS AND FEET.

4. LAST IS ANOTHER EXAMPLE OF THE GENERIC CHIBI WITH TAPERING LIMBS. THE LIMBS CAN TAPER TO NOTHING OR END UP IN VERY SMALL HANDS AND FEET. (EXAMPLES OF THE TAPERING LIMBS CAN BE FOUND IN THE FOLLOWING CHAPTERS).

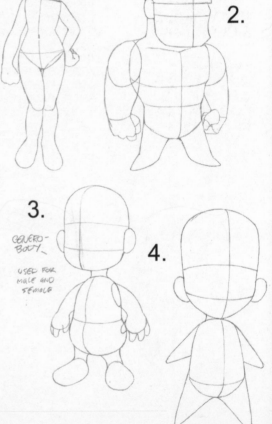

GENERO-BODY

USED FOR MALE AND FEMALE

GENERIC CHIBI BODIES

THESE TWO BODY TYPES ARE SUITABLE FOR PORTRAYING EITHER SEX.

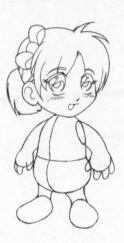

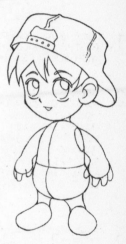

JUST LIKE IN REAL LIFE, MALE AND FEMALE BABIES AND SMALL CHILDREN ARE OFTEN DIFFICULT TO DISTINGUISH FROM EACH OTHER. THE ONLY WAY YOU CAN USUALLY TELL IS BY THEIR HAIR AND HOW THEY ARE DRESSED.

HOW TO DRAW CHIBI

ARMS AND HANDS

DRAWING ARMS AND HANDS IS VERY SIMPLE IF YOU REMEMBER ONE
BASIC RULE: CIRCLES! USING CIRCLES (AND OVALS), YOU CAN CREATE
ALMOST ANY HAND POSITION AND MAKE YOUR SMALL-BODIED
CHARACTER MORE DYNAMIC.

TUBE SECTIONED

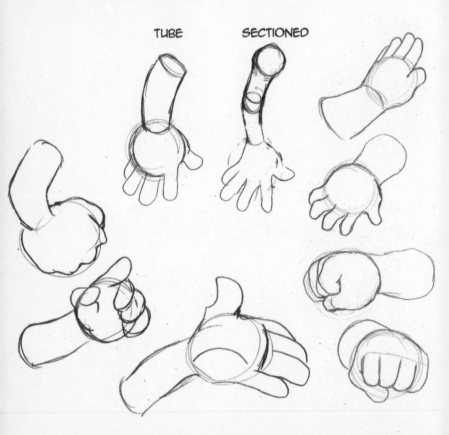

HOW TO DRAW CHIBI

HERE ARE SOME SAMPLE HANDS. THEY ARE SIMILAR TO THOSE
TAUGHT IN MOST CARTOONING AND ANIMATION BOOKS. IN FACT,
THESE HANDS COULD WELL BE THE SAME HANDS USED IN
DRAWING POPULAR CARTOON CHARACTERS. THESE HANDS SPORT
FOUR FINGERS, BUT FEEL FREE TO EXPERIMENT WITH THE CLASSIC
THREE-FINGERED TYPE--WHATEVER CATCHES YOUR FANCY.

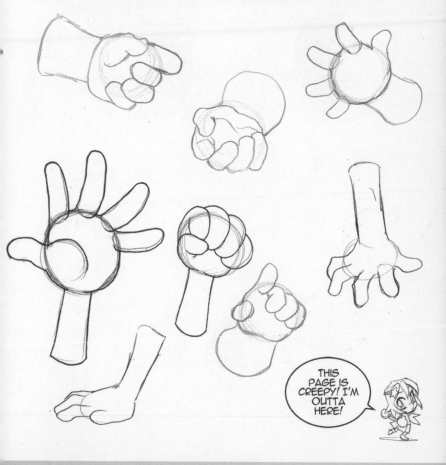

THIS PAGE IS CREEPY! I'M OUTTA HERE!

A COMMON MISTAKE OF MOST ARTISTS IS MASTERING THE SHOE SHAPE BEFORE MASTERING WHAT A FOOT LOOKS LIKE ON THE INSIDE. BELOW ARE SOME EXAMPLES OF CARTOON FEET WHICH CAN BE APPLIED TO ANY OF YOUR CHIBI DRAWINGS.

AN ARTIST CAN HIDE THE FEET OF HIS SUBJECTS BEHIND CLUNKY BOOTS ONLY SO OFTEN BEFORE THE TRICK BECOMES OLD HAT.

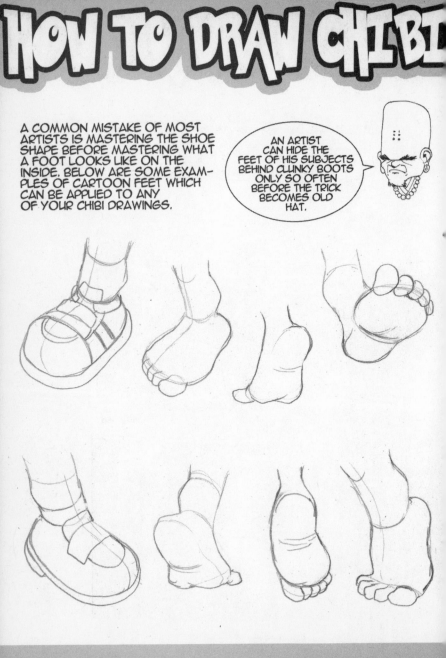

LEGS AND FEET

SIMILARLY TO ARMS AND HANDS, THE MAIN THING TO REMEMBER ABOUT FEET IS OVALS. YOU CAN DRAW THE FEET AND TOES USING A SERIES OF OVALS. WHEN DRAWING THIN OR SKINNY BODIES, IT IS GOOD TO USE SECTIONED LEGS AND FEET.

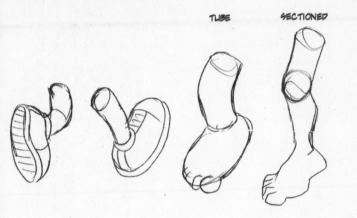

TUBE SECTIONED

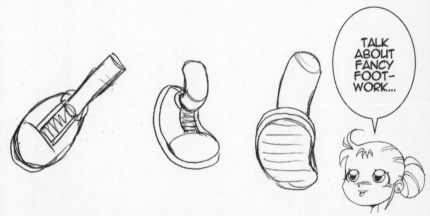

TALK ABOUT FANCY FOOT-WORK...

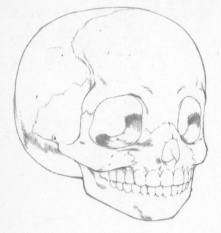

FOR THE MOST PART, YOU WON'T NEED TO BE DRAWING THE SKULLS OF YOUR CHIBI CHARACTERS LIKE THIS!

YEOW! I SURE HOPE NOT!

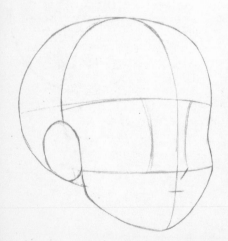

IN MOST CARTOONING, SKULLS ARE DRAWN AS REFERENCE POINTS, ALLOWING THE ARTIST TO POINT THE HEAD IN DIFFERENT DIRECTIONS AND MAINTAIN A CONSISTENT LOOK TO THE CHARACTER.

HOW TO DRAW CHIBI

HERE IS AN EXAMPLE OF A FEMALE CHIBI WITH CLOTHES. NOTE HOW EVEN THE CLOTHES ARE CUT LIKE A CHILD'S.

THE FEET OF THE SECOND CHIBI GIRL (BELOW) FOLLOW THE TAPERING MODEL.

SINCE CHIBI IS ABOUT EXAGGERATING THE MORE IMPORTANT FEATURES, THE FACE AND HEAD ARE USUALLY THE LARGEST PARTS. HANDS AND FEET ALMOST DISAPPEAR--UNTIL THEY ARE NEEDED, OF COURSE...

HOW TO DRAW CHIBI

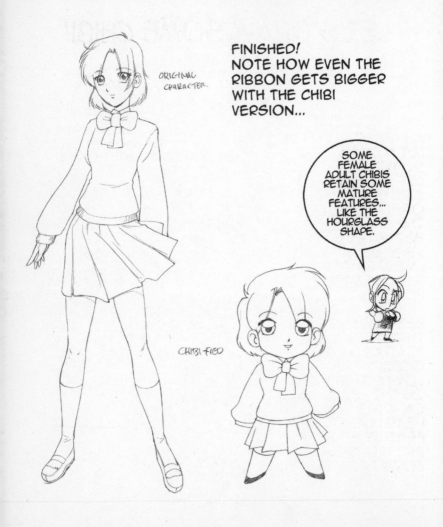

FINISHED!
NOTE HOW EVEN THE RIBBON GETS BIGGER WITH THE CHIBI VERSION...

SOME FEMALE ADULT CHIBIS RETAIN SOME MATURE FEATURES... LIKE THE HOURGLASS SHAPE.

ORIGINAL CHARACTER

CHIBI-FIED

LET'S DRAW SOME CHIBI!

YOU CAN ALSO DRAW HANDS AS NOTHING BUT CIRCULAR BALLS!

ALL RIGHT! LET'S DRAW SOME CHIBI! LET'S DRAW A GIRL FIRST. OBSERVE HOW THE SHAPE OF HER SKULL IS VERY MUCH LIKE A BABY'S, WITH A LARGE FOREHEAD.

KEEP IN MIND THAT THE FEATURES WILL OCCUPY THE LOWER THIRD OF THE HEAD. ON A NORMAL HEAD, THE FEATURES ARE MORE CENTERED.

PENCILING THE CHIBI IN MORE DETAIL, WE FILL IN THE MISSING PARTS. CLOTHING AND ACCESSORIES' POSITIONS ARE BASED ON THE BASIC FRAME WE SKETCHED IN EARLIER.

THE SKULL YOU CREATE WILL NOT ACCOUNT FOR THE VOLUME OF HAIR THE CHARACTER HAS.

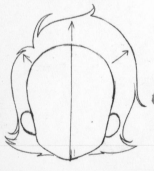

HOW TO DRAW CHIBI

NOTICE HOW
OUR FIGURE'S
BODY SHAPE
LOOKS NO
DIFFERENT
FROM A
TYPICAL
TODDLER'S.

TO REALLY
BRING OUT THE
CUTE EYES,
HAVE THE MAIN
HIGHLIGHT
COVER AT
LEAST HALF
THE IRIS.

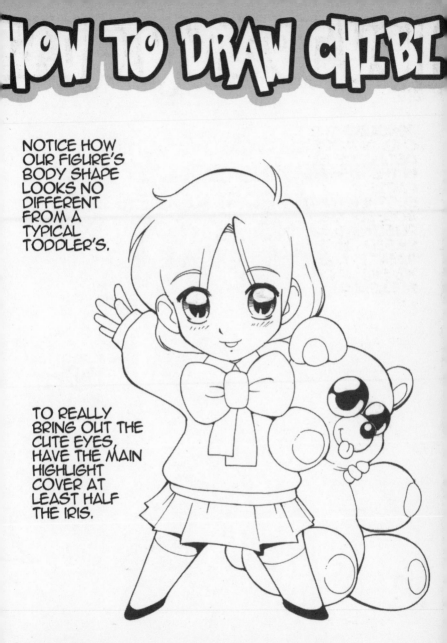

HOW TO DRAW CHIBI

BUT WAIT! IF CHIBI IS MAKING ADULTS' AND TEENAGERS' BODIES INTO CHILDREN'S, HOW DO I DRAW A CHIBI OF A CHILD?

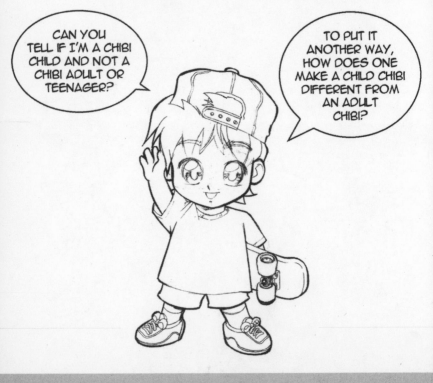

CAN YOU TELL IF I'M A CHIBI CHILD AND NOT A CHIBI ADULT OR TEENAGER?

TO PUT IT ANOTHER WAY, HOW DOES ONE MAKE A CHILD CHIBI DIFFERENT FROM AN ADULT CHIBI?

HOW TO DRAW CHIBI

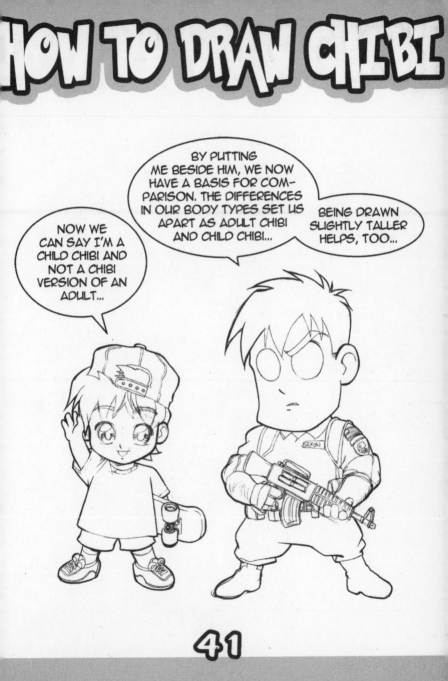

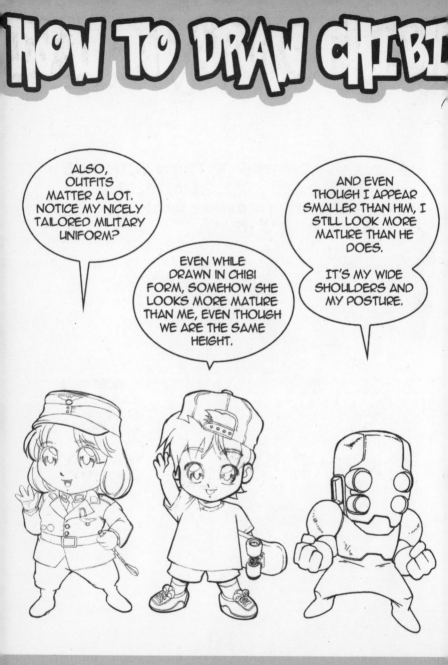

HOW TO DRAW CHIBI

WE CONCLUDE THIS SECTION WITH ONE LAST EXERCISE. WE'LL HAVE MORE STEP-BY-STEP DRAWING IN THE FOLLOWING CHAPTERS.

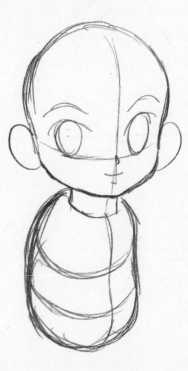

1: SKETCH A BASIC, ROUGH OUTLINE STARTING WITH THE HEAD AND BODY TYPE.

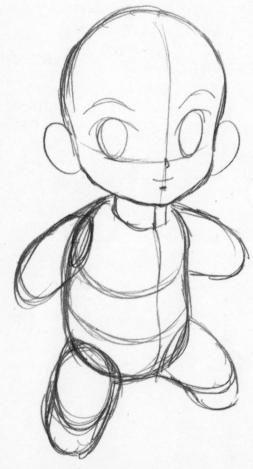

2: SKETCH
IN THE ARMS
AND LEGS

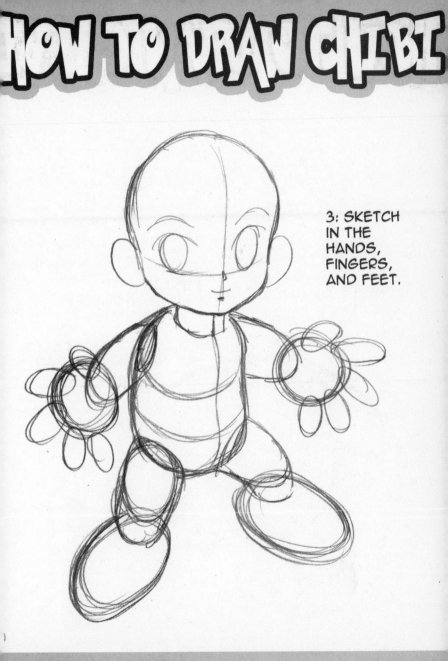

3: SKETCH
IN THE
HANDS,
FINGERS,
AND FEET.

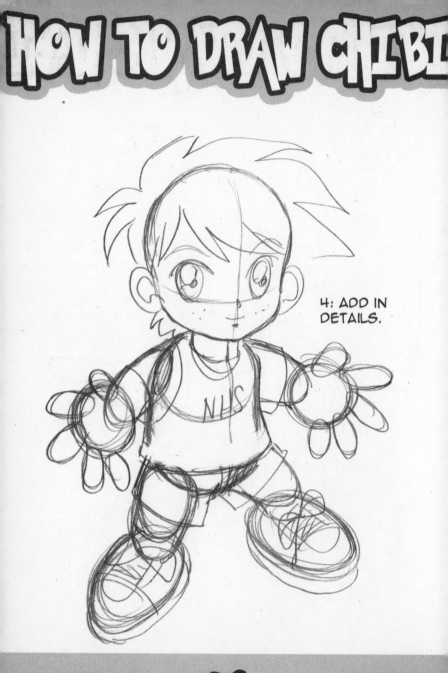

4: ADD IN DETAILS.

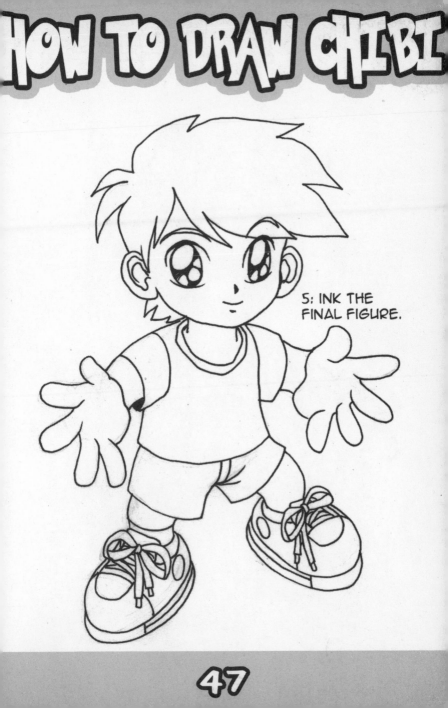

5: INK THE FINAL FIGURE.

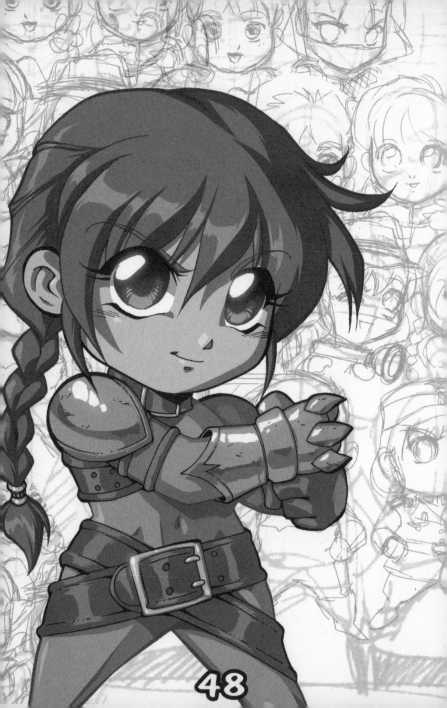

48

CHAPTER 3

FACIAL EXPRESSIONS AND POSES

ACTIONS AND MOODS--
CHIBI STYLE!

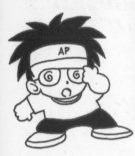

THE HEAD IS PERHAPS THE MOST IMPORTANT PART OF THE BODY IN TERMS OF EXPRESSING MOODS AND EMOTION. IT IS THE PART THAT PEOPLE SEE THE MOST EVERY DAY, AND IN MANGA, THE HEAD SAYS EVERYTHING ABOUT THE CHARACTER.

HAVING EXTREME EXPRESSIONS IS THE KEY TO PULLING OFF A CONVINCING CHIBI DRAWING. MANGA CHARACTERS ALREADY HAVE EXTREME EXPRESSIONS. NOW MAKE THEM A BIT MORE EXTREME IN THE CASE OF CHIBI, AND YOU'VE GOT A RECIPE FOR HILARITY!

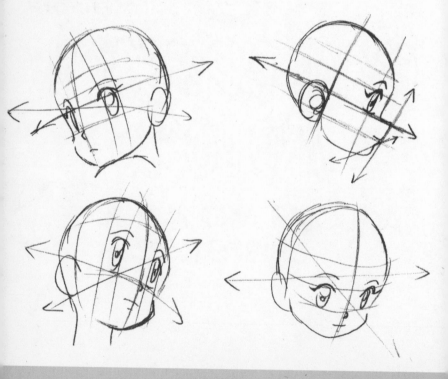

HOW TO DRAW CHIBI

CHARACTERS IN MOTION

THE SAME RULES FOR DRAWING FULL-SIZED FIGURES APPLY TO DRAWING CHIBI FIGURES IN MOTION.

DRAWING
CHARACTERS
IN SD FORM
ENHANCES
THE COMEDIC
ELEMENT IN A
PARTICULAR
SCENE.

HOW TO DRAW CHIBI

THE MANY FACES OF CHIBI!

IN THE FOLLOWING PAGES, WE WILL STUDY AND
REVIEW THE MANY EXPRESSIONS YOU CAN DRAW
TO MAKE YOUR COMICS MEMORABLE AND
ENTERTAINING.

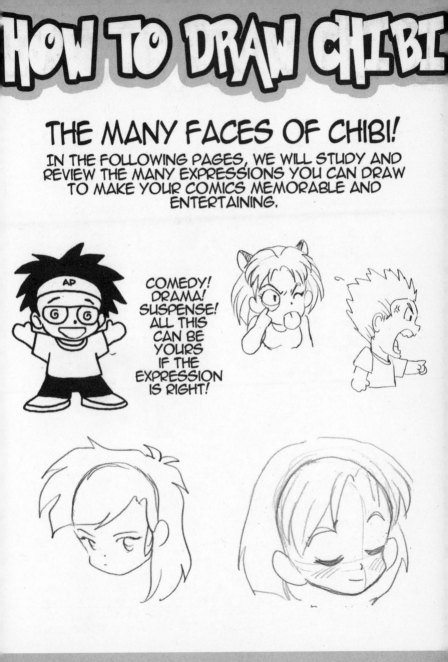

COMEDY!
DRAMA!
SUSPENSE!
ALL THIS
CAN BE
YOURS
IF THE
EXPRESSION
IS RIGHT!

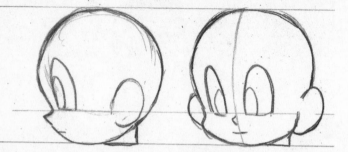

HEAD ANGLES... ONCE AGAIN, IT'S BACK TO THE BASICS FOR A WHILE. NOTE HOW THE FEATURES CHANGE OR ARE COVERED UP, DISTORTED AND ALTERED AS THE HEAD TURNS.

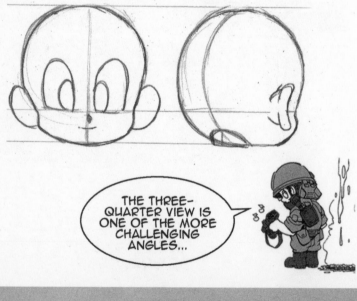

THE THREE-QUARTER VIEW IS ONE OF THE MORE CHALLENGING ANGLES...

HOW TO DRAW CHIBI

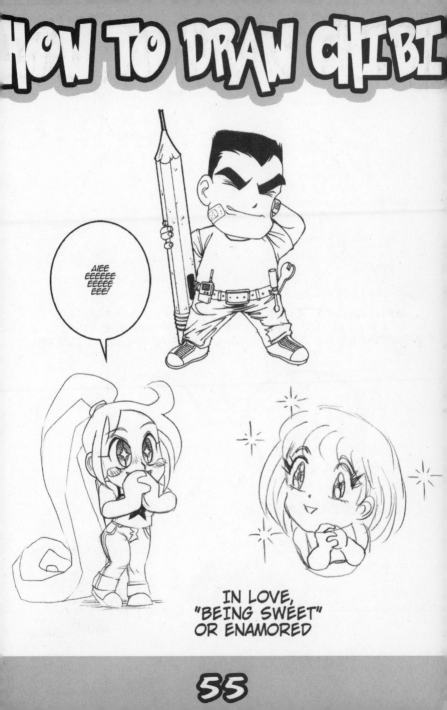

IN LOVE,
"BEING SWEET"
OR ENAMORED

55

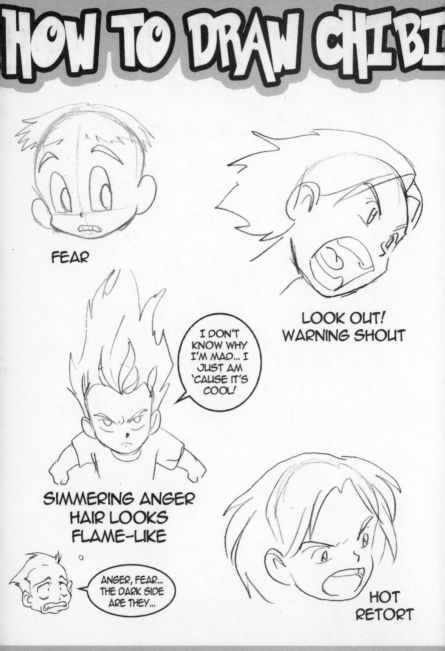

FEAR

LOOK OUT!
WARNING SHOUT

I DON'T KNOW WHY I'M MAD... I JUST AM 'CAUSE IT'S COOL!

SIMMERING ANGER
HAIR LOOKS
FLAME-LIKE

ANGER, FEAR...
THE DARK SIDE
ARE THEY...

HOT
RETORT

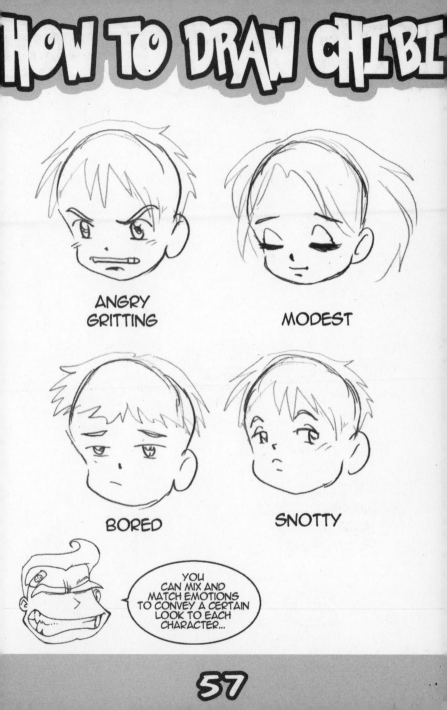

HOW TO DRAW CHIBI

BAWLING OUT!

(STREAMS OF TEARS ARE A STANDARD OF MANGA STORYTELLING.)

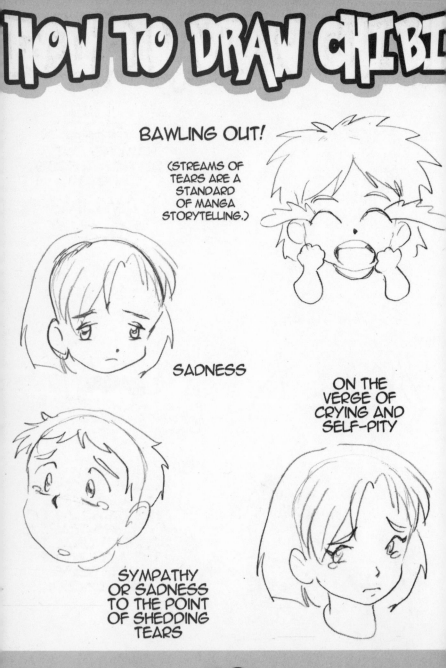

SADNESS

ON THE VERGE OF CRYING AND SELF-PITY

SYMPATHY OR SADNESS TO THE POINT OF SHEDDING TEARS

HOW TO DRAW CHIBI

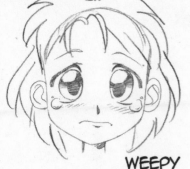

WEEPY

There's bawling out... and then there's, you know...

BAWLING OUT!

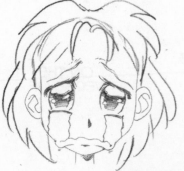

ABOUT TO EXPLODE

WHEN IT COMES TO CRYING IN MANGA, THE SHEER AMOUNT OF GEYSERING TEARS IS PROPORTIONAL TO THE AMOUNT OF GRIEF BEING EXPERIENCED!

THIS SECTION MAKES ME WEEPY...

CHIBI EXPRESSIONS

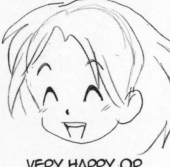

VERY HAPPY OR EXCITED

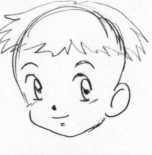

PLEASED

EATING WITH RELISH

CHATTERING AMIABLY

HAPPINESS IS A WARM COOKIE IN A GLASS OF MILK ON A COLD NIGHT...

HOW TO DRAW CHIBI

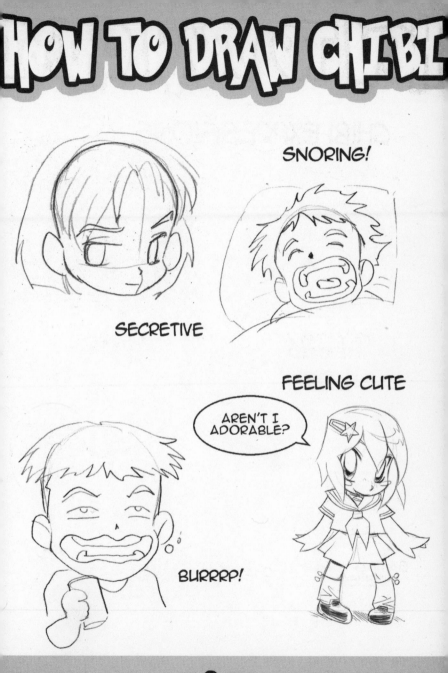

SNORING!

SECRETIVE

FEELING CUTE

AREN'T I ADORABLE?

BURRRP!

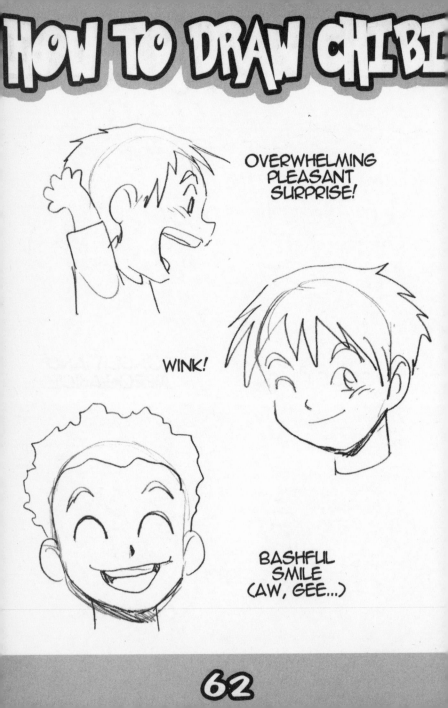

OVERWHELMING
PLEASANT
SURPRISE!

WINK!

BASHFUL
SMILE
(AW, GEE...)

HOW TO DRAW CHIBI

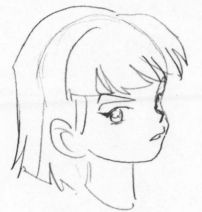

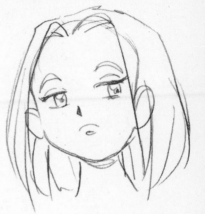

CONNIVING AND
GOSSIPING

CONCEIT AND
ARROGANCE

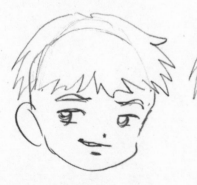

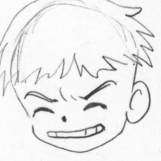

WILY

CACKLING

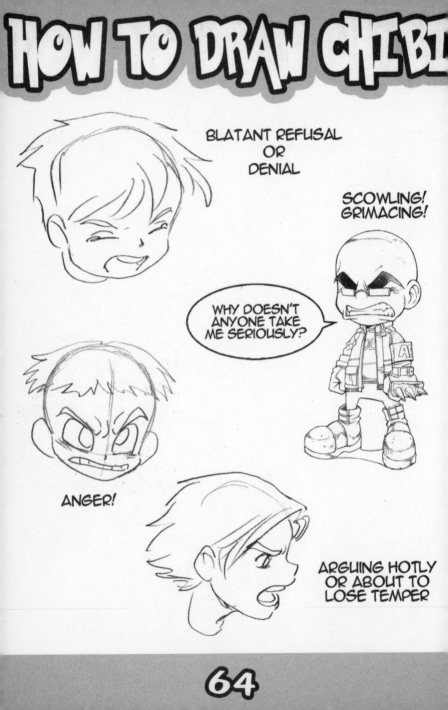

SURPRISE!

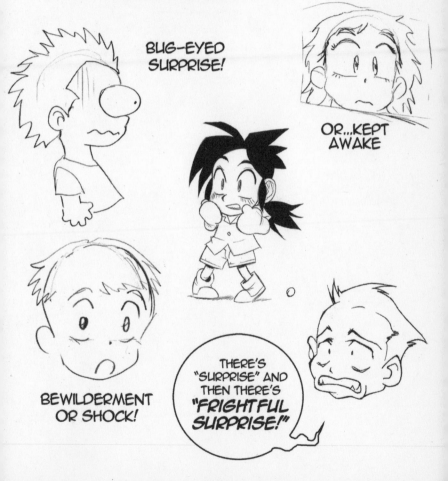

SURPRISE!!!

BUG-EYED SURPRISE!

OR...KEPT AWAKE

BEWILDERMENT OR SHOCK!

THERE'S "SURPRISE" AND THEN THERE'S *"FRIGHTFUL SURPRISE!"*

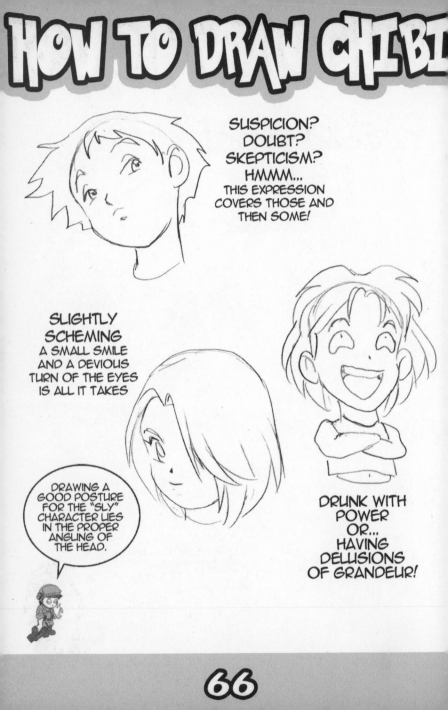

SUSPICION?
DOUBT?
SKEPTICISM?
HMMM...
THIS EXPRESSION COVERS THOSE AND THEN SOME!

SLIGHTLY SCHEMING
A SMALL SMILE AND A DEVIOUS TURN OF THE EYES IS ALL IT TAKES

DRAWING A GOOD POSTURE FOR THE "SLY" CHARACTER LIES IN THE PROPER ANGLING OF THE HEAD.

DRUNK WITH POWER OR... HAVING DELUSIONS OF GRANDEUR!

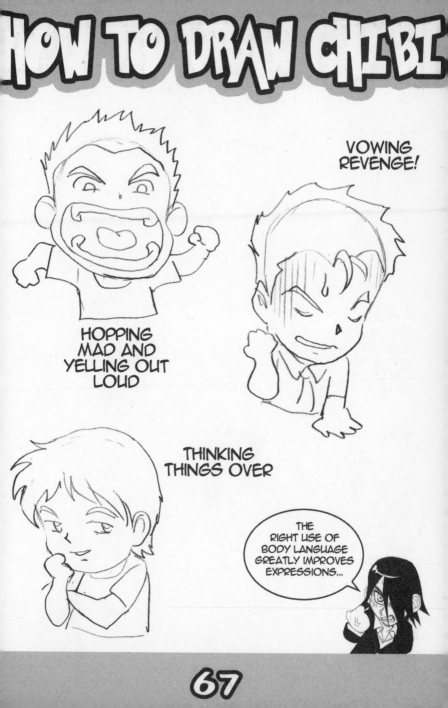

HOW TO DRAW CHIBI

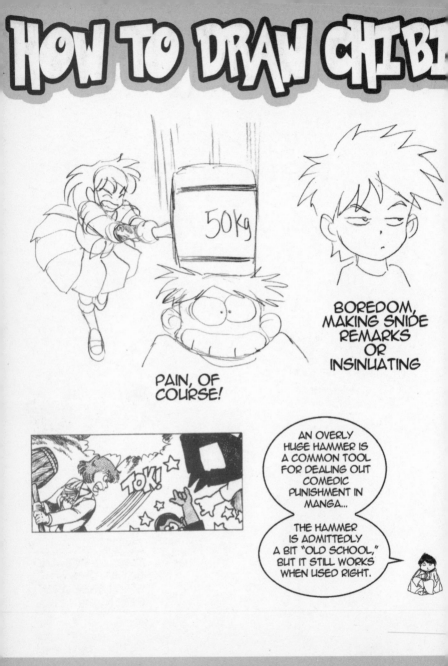

50Kg

PAIN, OF
COURSE!

BOREDOM,
MAKING SNIDE
REMARKS
OR
INSINUATING

TOK!

AN OVERLY
HUGE HAMMER IS
A COMMON TOOL
FOR DEALING OUT
COMEDIC
PUNISHMENT IN
MANGA...

THE HAMMER
IS ADMITTEDLY
A BIT "OLD SCHOOL,"
BUT IT STILL WORKS
WHEN USED RIGHT.

CHIBIS IN ACTION!

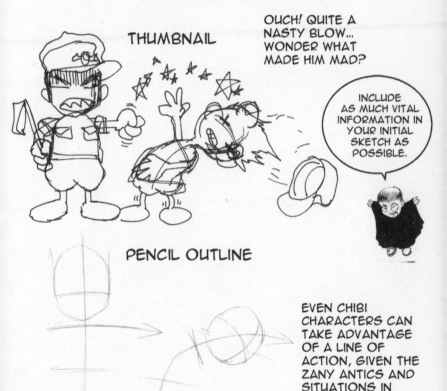

THUMBNAIL

OUCH! *QUITE A NASTY BLOW...* WONDER WHAT MADE HIM MAD?

INCLUDE AS MUCH VITAL INFORMATION IN YOUR INITIAL SKETCH AS POSSIBLE.

PENCIL OUTLINE

EVEN CHIBI CHARACTERS CAN TAKE ADVANTAGE OF A LINE OF ACTION, GIVEN THE ZANY ANTICS AND SITUATIONS IN WHICH THEY ARE OFTEN INVOLVED.

ANYWAY, CHIBI DRAWINGS ARE GOOD FOR EXPRESSING EXTREME ACTIONS LIKE THIS. IT LOOKS COMEDIC AND THE IMAGE OF VIOLENCE IS SOMEHOW LESSENED.

PAY CLOSE ATTENTION TO THE DETAILS OF ACTION AND REACTION IN YOUR DRAWINGS. THIS CAN REALLY HELP REFINE YOUR ILLUSTRATIONS!

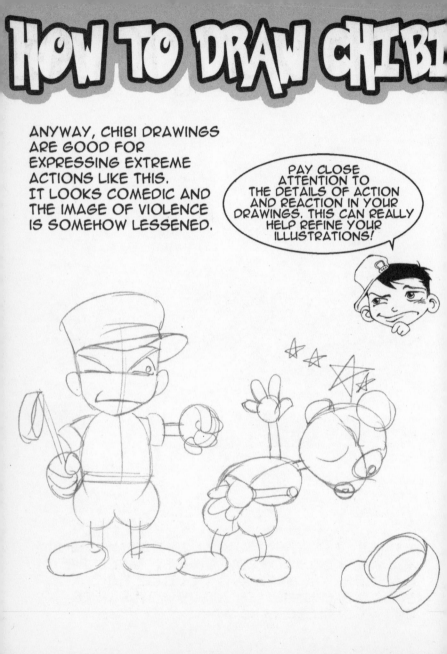

HOW TO DRAW CHIBI

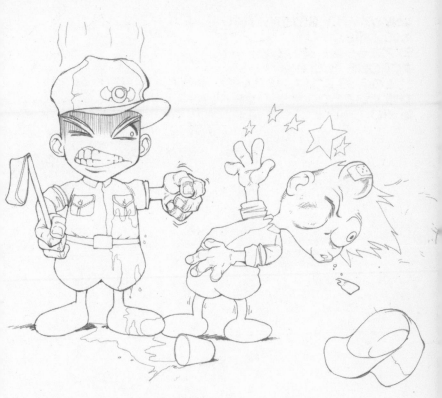

HAVING CARTOON CHARACTERS TAKE MASSIVE
BLOWS IN THIS COMEDIC MANNER TAKES THE
EDGE OFF THE APPARENT VIOLENCE THAT
WOULD OTHERWISE SHOCK US IF THIS WERE
DRAWN IN A REALISTIC WAY.

THE MULTIPLE FOOT RUN!

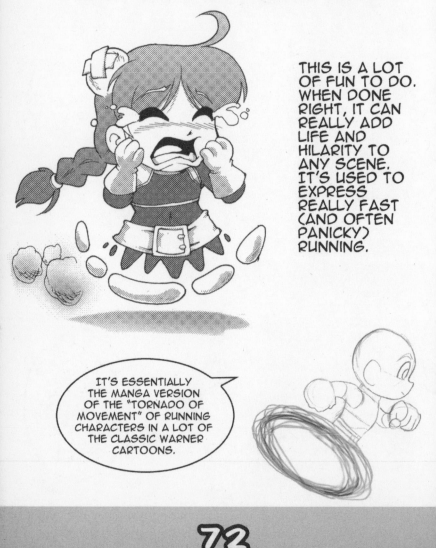

THIS IS A LOT OF FUN TO DO. WHEN DONE RIGHT, IT CAN REALLY ADD LIFE AND HILARITY TO ANY SCENE. IT'S USED TO EXPRESS REALLY FAST (AND OFTEN PANICKY) RUNNING.

IT'S ESSENTIALLY THE MANGA VERSION OF THE "TORNADO OF MOVEMENT" OF RUNNING CHARACTERS IN A LOT OF THE CLASSIC WARNER CARTOONS.

HOW TO DRAW CHIBI

THE NOSEBLEED
OF HYPEREXCITEMENT!

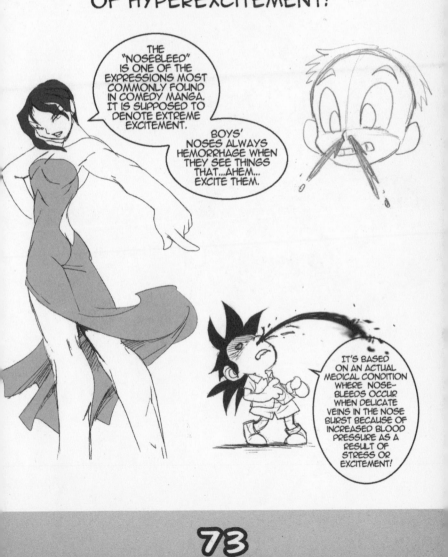

THE "NOSEBLEED" IS ONE OF THE EXPRESSIONS MOST COMMONLY FOUND IN COMEDY MANGA. IT IS SUPPOSED TO DENOTE EXTREME EXCITEMENT.

BOYS' NOSES ALWAYS HEMORRHAGE WHEN THEY SEE THINGS THAT...AHEM... EXCITE THEM.

IT'S BASED ON AN ACTUAL MEDICAL CONDITION WHERE NOSE-BLEEDS OCCUR WHEN DELICATE VEINS IN THE NOSE BURST BECAUSE OF INCREASED BLOOD PRESSURE AS A RESULT OF STRESS OR EXCITEMENT!

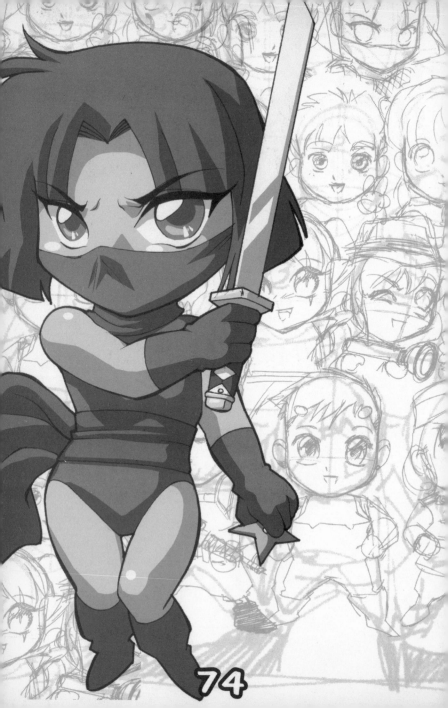

74

CHAPTER 4

COSTUMES

DRESSING UP YOUR CHARACTERS

HOW TO DRAW CHIBI

HOW TO DRAW CHIBI

AS YOU HAVE SEEN IN THE LAST CHAPTER, THERE ARE LOTS OF EXPRESSIONS. IT IS IMPOSSIBLE FOR ANY ONE BOOK TO LIST AND SHOW THEM ALL. WHAT WE JUST SHOWED YOU IS LITERALLY THE TIP OF THE ICEBERG. THERE ARE COUNTLESS MORE WAYS TO EXPRESS THE VAST RANGE OF FACIAL EMOTIONS.

BUT REALLY... WHAT ARE EXPRESSIONS WITHOUT THE PROPER BODY LANGUAGE? FOR THAT MATTER, WITHOUT PROPER ATTIRE? IN THIS CHAPTER, WE'LL DISCUSS COSTUME AND HOW IT PLAYS A VITAL ROLE IN MAKING YOUR CHIBIS COME TO LIFE.

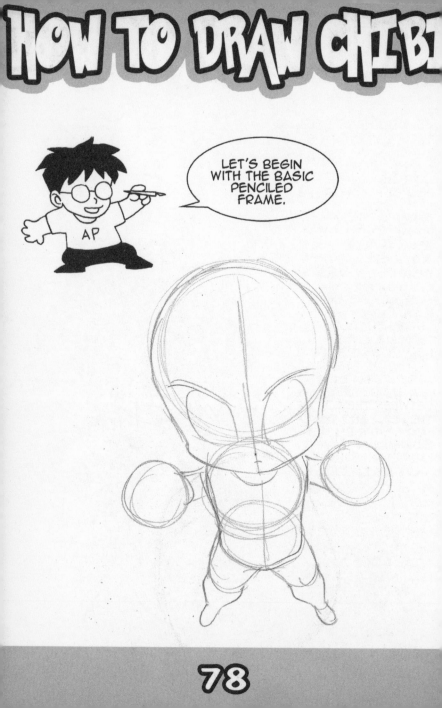

HOW TO DRAW CHIBI

NOTE HOW THE HELMET EXCEEDS THE SKULL SIZE. REMEMBER TO FIT THE HELMET ONTO THE HEAD, NOT THE HEAD INTO THE HELMET. WHAT THIS MEANS IS, DRAW THE HEAD FIRST, AND ONCE YOUR DRAWING LOOKS CORRECT, THEN BUILD THE HELMET ON TOP OF IT.

ALSO, REMEMBER TO LEAVE A LITTLE ROOM BETWEEN THE TOP OF THE HEAD AND THE TOP OF THE HELMET. ACCOUNT FOR THE SKULL, SKIN, HAIR, AND HELMET PADDING.

HAVING THE BASIC WIRE FRAME IN PLACE GIVES YOU A REFERENCE POINT FOR DRAWING IN YOUR OUTFIT.

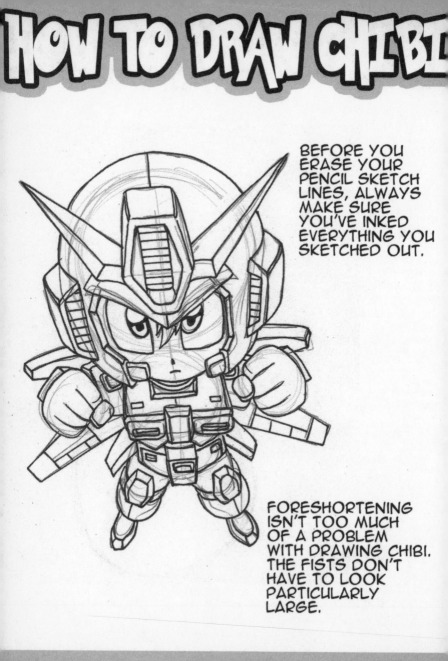

BEFORE YOU ERASE YOUR PENCIL SKETCH LINES, ALWAYS MAKE SURE YOU'VE INKED EVERYTHING YOU SKETCHED OUT.

FORESHORTENING ISN'T TOO MUCH OF A PROBLEM WITH DRAWING CHIBI. THE FISTS DON'T HAVE TO LOOK PARTICULARLY LARGE.

THE FINAL
PIECE
FINISHED.

MECH SUITS
ARE FAIRLY
COMMON IN
MANGA AND
ANIME. IT'S
ONLY PROPER
TO INCLUDE
ONE HERE.

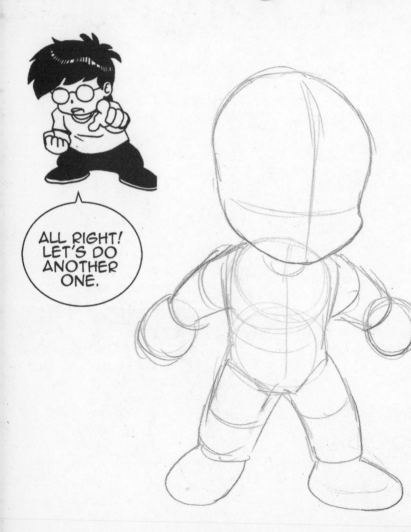

ALL RIGHT!
LET'S DO
ANOTHER
ONE.

HOW TO DRAW CHIBI

ONCE AGAIN,
NOTE HOW THE
CLOTHES ARE
DRAWN
THICKER THAN
THE PENCILLED
OUTLINE.

STAGE THREE:
INKING. LOOK AT
HOW THE HELMET
SITS WELL ON TOP
OF THE SUIT. THIS
IS WHERE THE
BASIC PENCIL
SKETCH PAYS OFF.
HAVING THE NECK
PENCILED IN THERE
HELPS POSITION
THE HELMET.

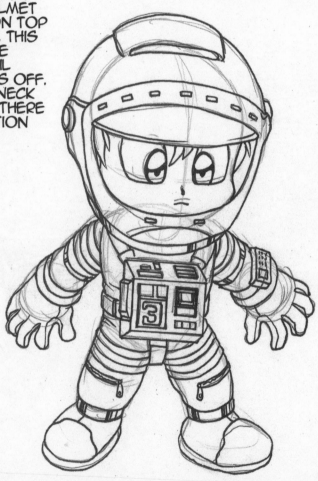

BLACKS ARE FILLED IN LAST. ONCE YOU FILL THOSE IN, YOU'RE DONE!

SEE HOW THE USE OF SOLID BLACK GIVES THE INTERIOR OF THE HELMET A BIT OF DEPTH? IT ALSO POPS OUT THE STRAPS AND GIVES THEM EXTRA EMPHASIS.

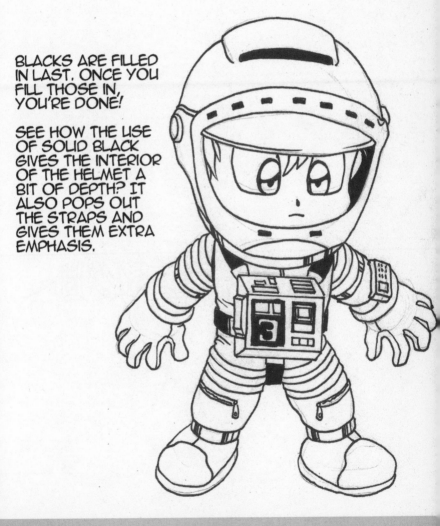

S.W.A.T. GIRL

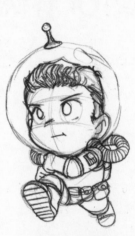

HERE'S MORE EXAMPLES OF DIFFERENT COSTUMES. TRY TO USE REFERENCE WHENEVER POSSIBLE. JUST BECAUSE IT'S CHIBI DOESN'T MEAN YOU SHOULDN'T TRY AND GET IT ACCURATE!

SPACE CONQUEROR

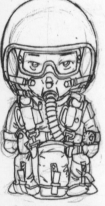

S.E.A.L. HALO

HALL MONITOR

SKETCHING OFTEN SHARPENS YOUR SKILLS FASTER!

CARTOON REALISM

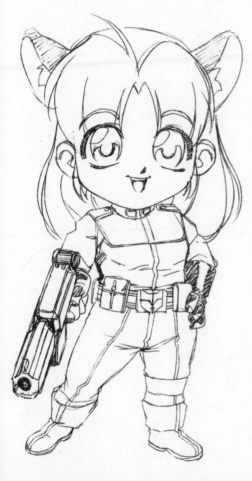

IT IS NOT UNCOMMON TO HAVE CHIBI CHARACTERS DECKED OUT WITH WHAT LOOKS LIKE REALISTIC EQUIPMENT.

TECHNICAL REALISM IS WHAT SEPARATES JAPANESE MANGA FROM MOST OF ITS WESTERN COUNTERPARTS.

CHIBI IN SOLDIER UNIFORM

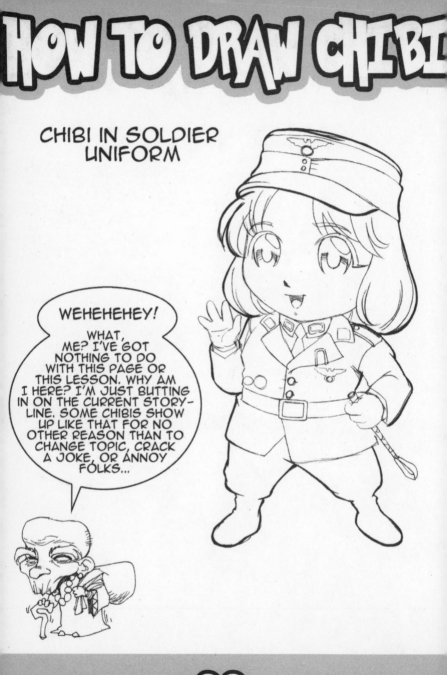

WEHEHEHEY!

WHAT, ME? I'VE GOT NOTHING TO DO WITH THIS PAGE OR THIS LESSON. WHY AM I HERE? I'M JUST BUTTING IN ON THE CURRENT STORY-LINE. SOME CHIBIS SHOW UP LIKE THAT FOR NO OTHER REASON THAN TO CHANGE TOPIC, CRACK A JOKE, OR ANNOY FOLKS...

HOW TO DRAW CHIBI

GIRL NINJA

HERE IS ANOTHER EXAMPLE OF REALISTIC EQUIPMENT WITH CARTOON CHARACTERS.

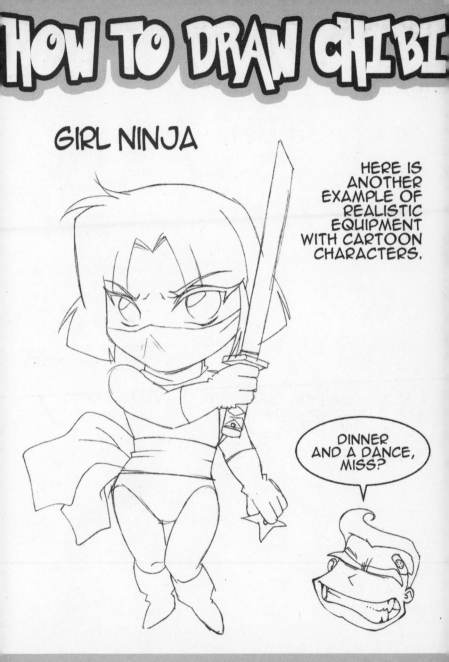

DINNER AND A DANCE, MISS?

HOW TO DRAW CHIBI

CATGIRL CHIBI!

ONE OF THE MOST ENDURING MANGA-TYPE CHARACTERS IS KNOWN AS THE "NEKO-MIMI" (LIT.: "CAT EARS") OR THE "CAT-GIRL." THEY ARE USUALLY VERY CUTE AND SPIRITED CHARACTERS AND ADD A SENSE OF QUIRKINESS TO ANY MANGA STORY.

THERE ARE CERTAINLY MANY TYPES OF FURRY GIRLS, BUT CATS SEEM TO FIT FEMALES THE BEST, SINCE FEMALES TEND TO BE CATLIKE IN MANGA. SHOWN HERE ARE THE BASICS TO START YOUR OWN CAT-GIRL CHARACTER! MEOW! MEOW!

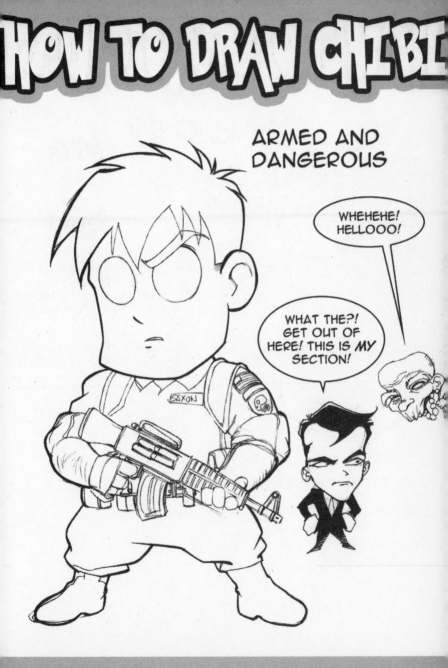

A "BITE-SIZED" VAMPIRE!

DON'T BE AFRAID TO MAKE MISTAKES. IT'S ALL PART OF LEARNING.

SOME ARTISTS DRAW WITH PLENTY OF SKETCH LINES, WHILE OTHERS GET THE SHAPE THEY WANT ALMOST RIGHT AT THE START. WE'RE ALL DIFFERENT, AND WE ALL PROGRESS AT DIFFERENT RATES. THE KEY IS JUST TO HAVE FUN.

DRAWING IN
DETAILS IS ONE OF
THE MOST FUN
THINGS TO DO.
IT'S ONE OF THE
MANY JOYS OF
BEING AN ARTIST.

INK THE
LINES IN.

WE'RE
ALMOST
READY TO
BITE!

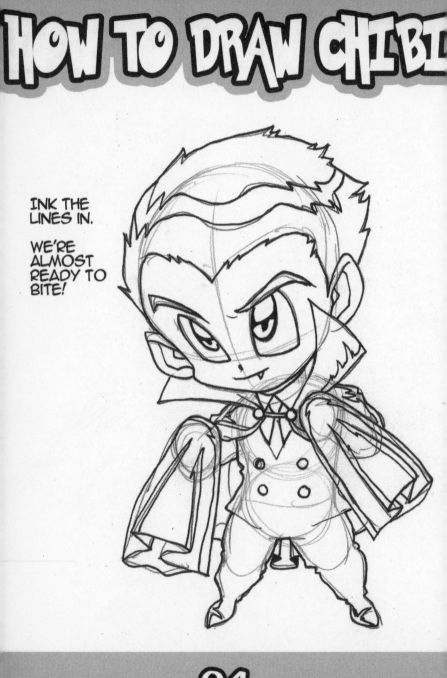

HOW TO DRAW CHIBI

CLEAN UP
WITH A GOOD
BRAND OF
ERASER.

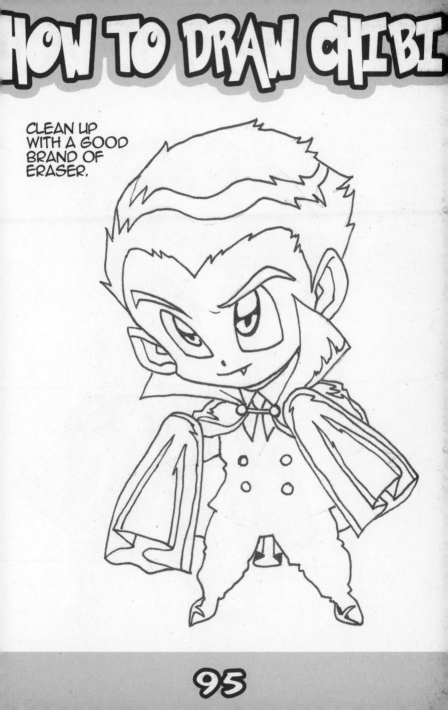

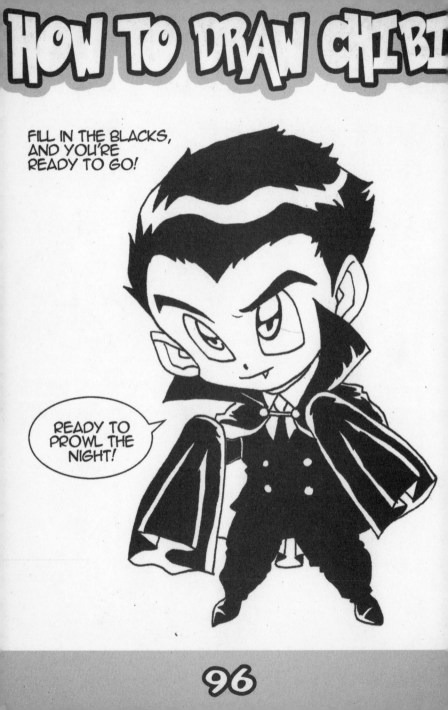

HOW TO DRAW CHIBI

CHIBI TREASURE-HUNTER

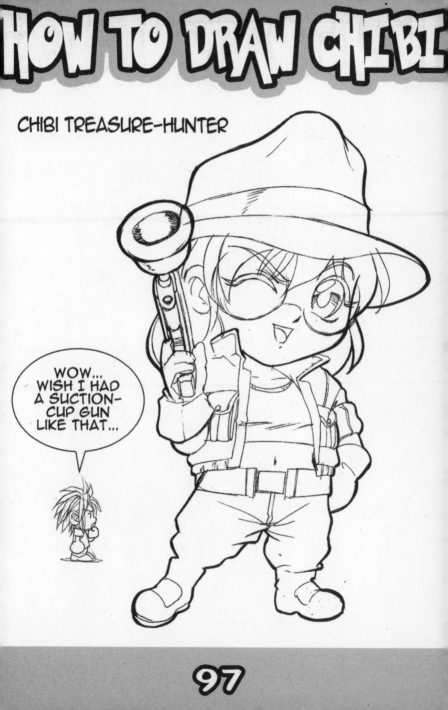

WOW...
WISH I HAD
A SUCTION-
CUP GUN
LIKE THAT...

HOW TO DRAW CHIBI

PINT-SIZED WARRIOR PRINCESS!

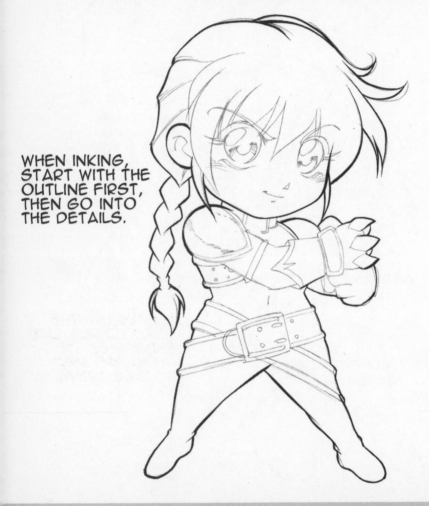

WHEN INKING,
START WITH THE
OUTLINE FIRST,
THEN GO INTO
THE DETAILS.

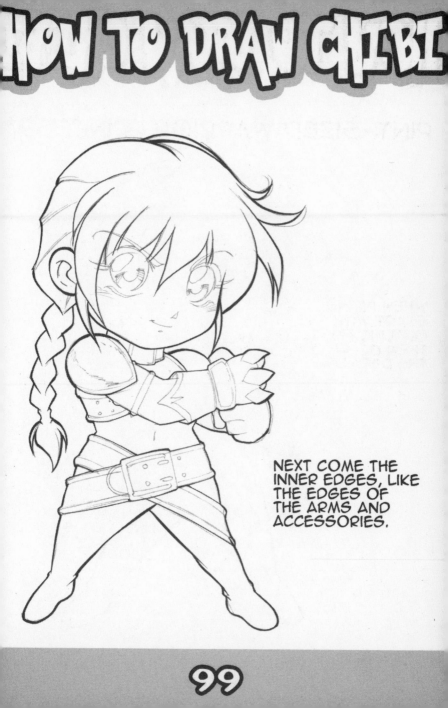

NEXT COME THE INNER EDGES, LIKE THE EDGES OF THE ARMS AND ACCESSORIES.

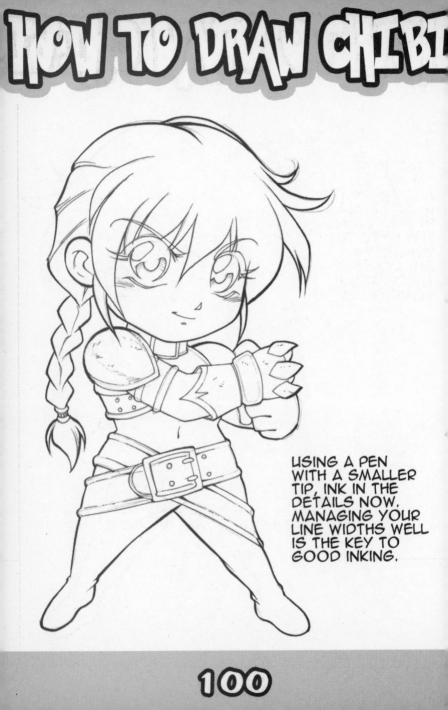

USING A PEN
WITH A SMALLER
TIP, INK IN THE
DETAILS NOW.
MANAGING YOUR
LINE WIDTHS WELL
IS THE KEY TO
GOOD INKING.

HOW TO DRAW CHIBI

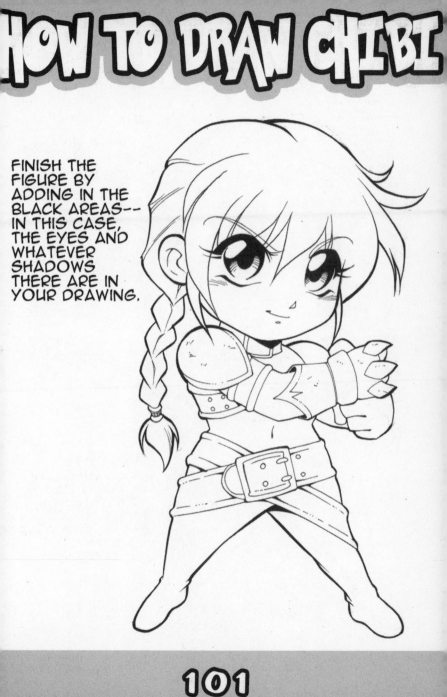

FINISH THE FIGURE BY ADDING IN THE BLACK AREAS-- IN THIS CASE, THE EYES AND WHATEVER SHADOWS THERE ARE IN YOUR DRAWING.

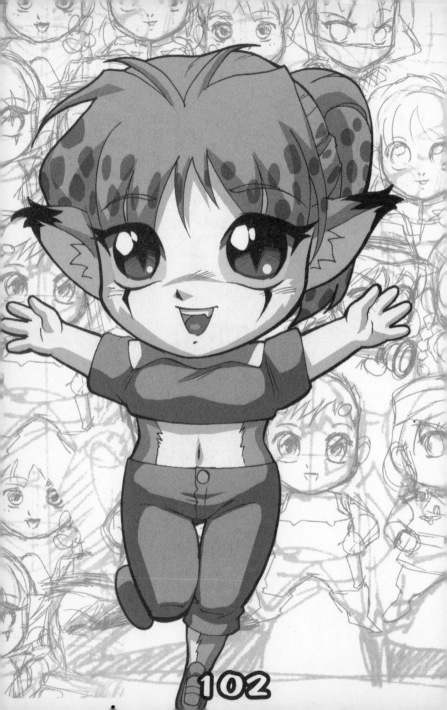

102

CHAPTER 5

CHIBI VARIANTS

CHIBIFYING OTHER TYPES OF CREATURES

HOW TO DRAW CHIBI

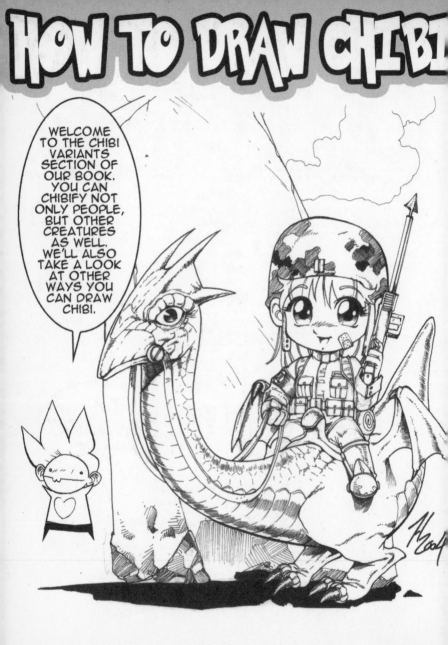

WELCOME TO THE CHIBI VARIANTS SECTION OF OUR BOOK. YOU CAN CHIBIFY NOT ONLY PEOPLE, BUT OTHER CREATURES AS WELL. WE'LL ALSO TAKE A LOOK AT OTHER WAYS YOU CAN DRAW CHIBI.

HOW TO DRAW CHIBI

AS YOU CAN SEE, THERE ARE MORE VARIANTS TO CHIBI THAN JUST CHANGING COSTUMES. SEE HOW WE'RE DRAWN? WE'RE A VARIANT OF THE TAPERING LIMB CHIBI.

ANTARCTIC PRESS
7272 WURZBACK #204
SAN ANTONIO, TX 76240

I'M BAAAACK! HEHEHE!

CHIBI ANIMALS

EVEN ANIMALS CAN BE CHIBIFIED. IT'S SIMILAR TO CARTOONING ANIMALS, ONLY CHIBIFIED ANIMALS HAVE MANGA-STYLED EYES.

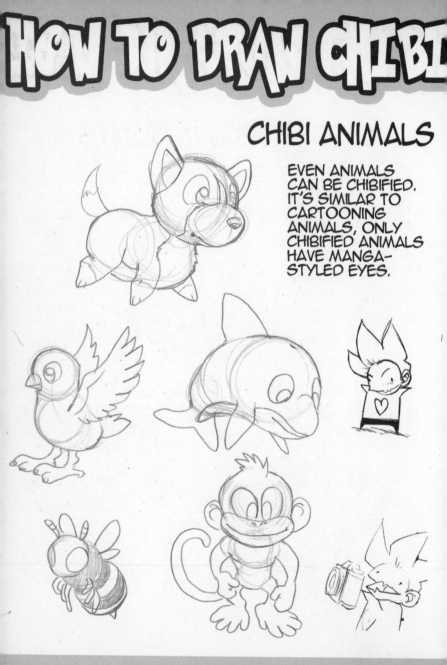

CHIBI ANIMAL MUTANTS

AS YOU CAN SEE, THE MANGA WORLD IS FULL OF TWISTS AND TURNS. NOT ONLY CAN YOU CHIBIFY AN ANIMAL, YOU CAN MUTATE IT AS WELL!

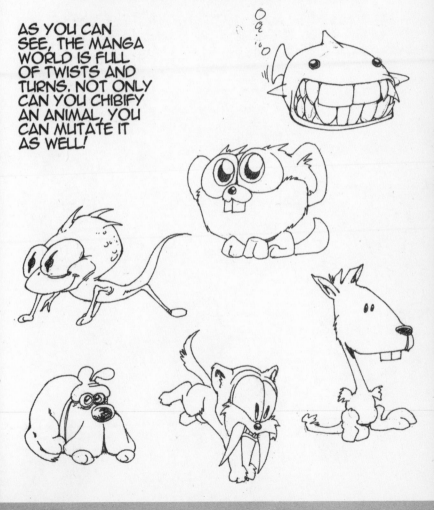

HOW TO DRAW CHIBI

MORE CHIBI VARIANTS!

MORE VARIANTS! MAN, THE POSSIBILITIES ARE
ENDLESS WHEN IT COMES TO MANGA AND CHIBI! HERE
ARE A FEW MORE YOU CAN TRY OUT.

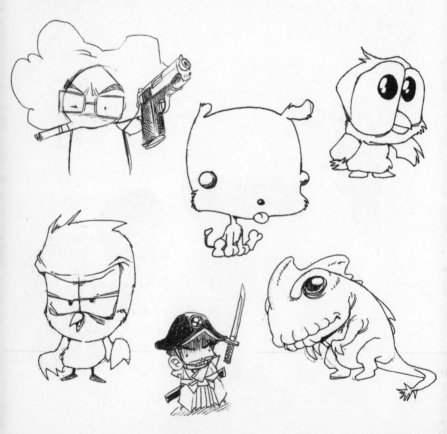

HOW TO DRAW CHIBI

MORE CHIBI VARIANTS

AS ALWAYS, THE EMPHASIS IS ON THE HEADS.

HERE, THE HEAD IS EVEN LARGER THAN THE WHOLE BODY!

HOW TO DRAW CHIBI

SOME ARE LITTLE MORE THAN HEADS WITH ARMS AND LEGS ATTACHED TO THEM.
TAKE A LOOK AT THE PENGUIN CHIBI AT THE UPPER RIGHT.

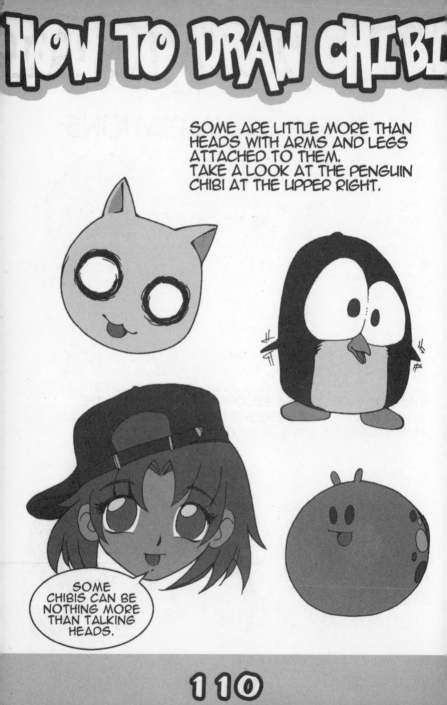

SOME CHIBIS CAN BE NOTHING MORE THAN TALKING HEADS.

HOW TO DRAW CHIBI

CHIBI FACE VARIATIONS

CHIBI FACES CAN ALSO BE DRAWN IN DIFFERENT WAYS. OUR FIRST SUBJECT IS DRAWN THE USUAL WAY, BUT FEEL FREE TO EXPERIMENT WITH OTHER CHIBI DRAWING STYLES.

NOTICE HOW SLIGHTLY DIFFERENT THE FACES IN THE DRAWINGS BELOW ARE FROM THE ONE ABOVE? PAY CLOSE ATTENTION TO THE EYES AND THE ABSENCE OF THE NOSE ON THOSE BELOW. THE FIGURE ON THE BOTTOM RIGHT HAS EYES THAT ARE ARE JUST PLAIN BLACK CIRCLES WITH ONLY ONE HIGHLIGHT.

111

CHIBI VARIANTS

THE REAL TRICK TO DRAWING ANYTHING CHIBI IS FIGURING OUT WHAT FEATURES ARE THE MOST PROMINENT AND EXAGGERATING THEM.

ROBOT CHIBIS ARE
ALSO POPULAR.
THE SAME RULES
OF PROPORTION
APPLY. ALSO,
MAKE THE EYES
LARGE WHENEVER
POSSIBLE.

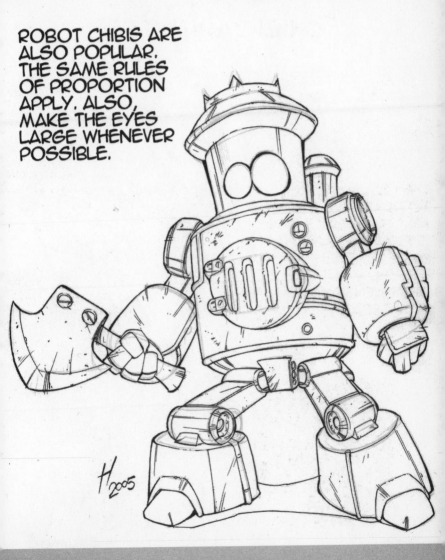

CHAPTER 6

MINI PROPS

CARTOONING EVERYDAY OJECTS

HOW TO DRAW CHIBI

CHIBI PROPS!

WHAT'S A GOOD CHIBI WITHOUT CHIBI PROPS?

DRAWING CHIBIS IS A LOT OF FUN, BUT WE CAN KICK IT UP A NOTCH WITH THE ADDITION OF PINT-SIZED CARTOON PROPS TO GO WITH YOUR LOVABLE CHARACTERS.

MINI TRAINS

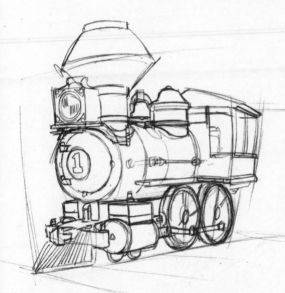

THE LITTLE TRAIN THAT CAN! MINI TRAINS ARE THE STUFF OF CLASSIC CHILDHOOD ADVENTURE FANTASIES. HERE'S ONE FOR YOUR CHIBIFICATION EDUCATION.

CHOO-CHOOOO!

ONCE YOU LOOK AT ANY VEHICLE OR PROP, IT'S EASY TO FIGURE OUT HOW TO BREAK IT DOWN INTO ITS BASIC SHAPES. THE TRAIN IS ONE OF THE EASIER OBJECTS TO BREAK DOWN BECAUSE IT IS ESSENTIALLY ALREADY CIRCLES AND CYLINDERS.

HOW TO DRAW CHIBI

CHOO-CHOO CHIBI-CHIBI...

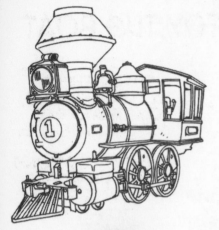

YOU DON'T HAVE TO GO ALL THE WAY LIKE WE DID HERE WITH THE ULTRA-DETAILED SHADING. WE JUST WANTED TO FINISH OFF THE ILLUSTRATION AND GIVE IT A NICE POLISHED SHEEN.

AWESOME!

HOW TO DRAW CHIBI

TOY TUG BOAT

RIGHT UP THERE
WITH MINI-TRAINS,
TOY BOATS ARE
ALSO A FAVORITE.

THE PROPORTIONS
ARE SHRUNK, BUT
NOT DISTORTED.

WAIT
FOR ME! I
WANNA RIDE
TOO!

WAIT!
YOUR INSURANCE
DOESN'T COVER
DROWNING!

HOW TO DRAW CHIBI

ADDING REALISTIC DETAILING EVEN ON CARTOON OBJECTS IS WHAT SEPARATES MANGA ILLUSTRATION FROM MOST OTHER COMIC STYLES.

NOTE THE ACCURATELY DRAWN LOBSTER CAGES AND THE USED TIRE ON THE SIDE OF THE BOAT...

TITAN II

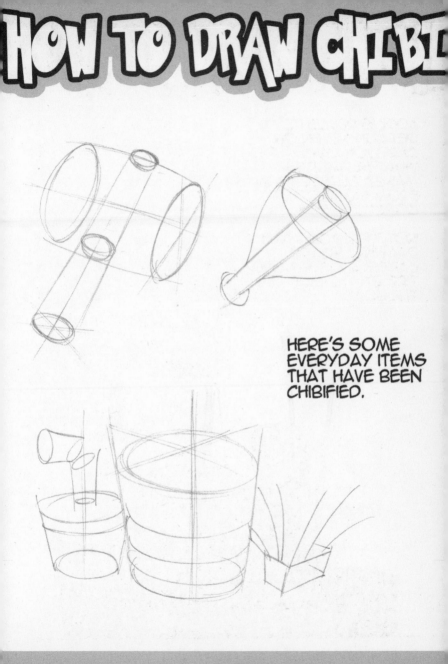

HERE'S SOME
EVERYDAY ITEMS
THAT HAVE BEEN
CHIBIFIED.

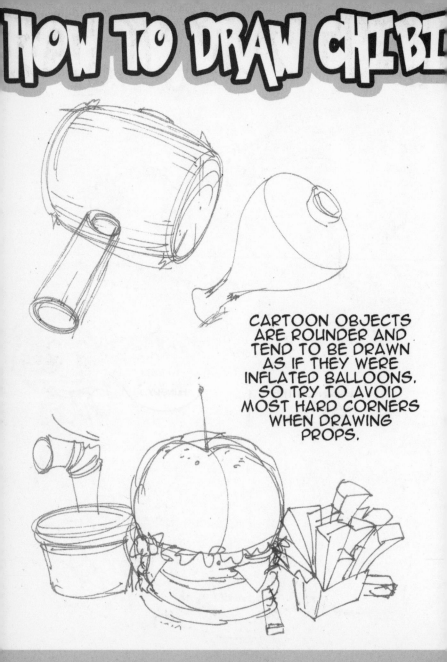

CARTOON OBJECTS ARE ROUNDER AND TEND TO BE DRAWN AS IF THEY WERE INFLATED BALLOONS. SO TRY TO AVOID MOST HARD CORNERS WHEN DRAWING PROPS.

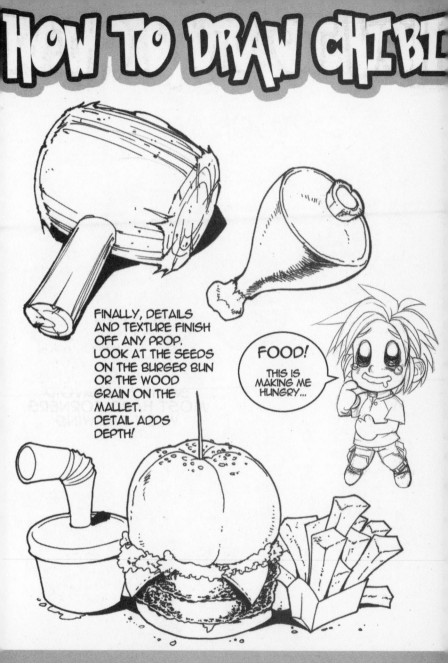

FINALLY, DETAILS AND TEXTURE FINISH OFF ANY PROP. LOOK AT THE SEEDS ON THE BURGER BUN OR THE WOOD GRAIN ON THE MALLET. DETAIL ADDS DEPTH!

FOOD! THIS IS MAKING ME HUNGRY...

CARTOON CARS!

DRIVING YOUR OWN LITTLE CAR IS WHAT CHILDHOOD DREAMS ARE MADE OF. HERE IN THE U.S., WE SELL MORE MATCHBOX™ CARS THAN TRAINS AND BOATS PUT TOGETHER!

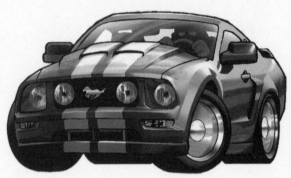

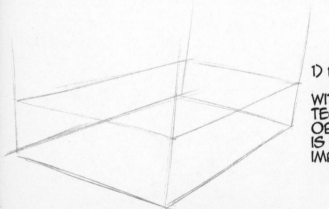

1) BASIC FRAME.

WITH CARS AND TECHNICAL OBJECTS, THIS IS VERY, VERY IMPORTANT!

DRAWING THE
WHEELS USING A
LONG CYLINDER
LIKE THIS ENSURES
GOOD WHEEL
ALIGNMENT.

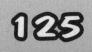

HAVING A BOX FRAME AS REFERENCE ENSURES PROPER DRAWING OF THE CURVED PARTS OF YOUR CARTOON CAR.

EVEN WITH CARTOONING, IT IS VERY IMPORTANT TO HAVE A BASIC FRAMEWORK.

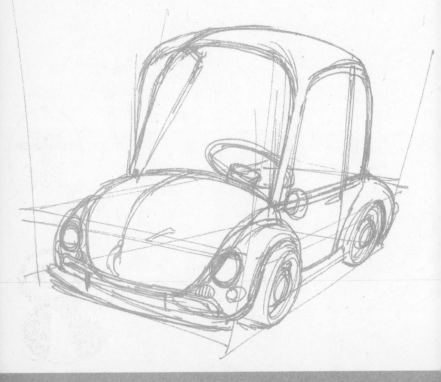

HOW TO DRAW CHIBI

IF YOU HAVE CHARACTERS IN THE CAR, YOU SHOULD ENLARGE THE AREA WHERE THEY WILL BE SITTING SO WE CAN SEE THEM THROUGH THE WINDOWS.

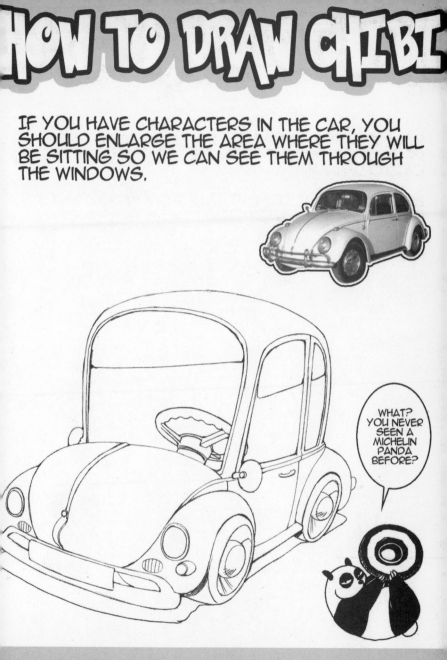

WHAT? YOU NEVER SEEN A MICHELIN PANDA BEFORE?

CARTOON BUILDINGS

THE FISHEYE LENS EFFECT IS A GOOD WAY TO DRAW CARTOON HOUSES.

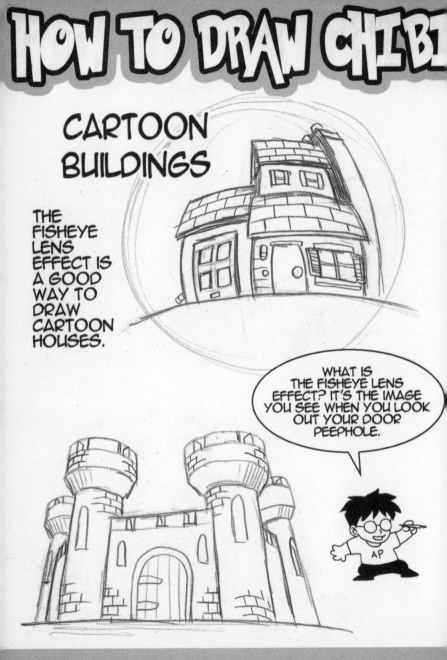

WHAT IS THE FISHEYE LENS EFFECT? IT'S THE IMAGE YOU SEE WHEN YOU LOOK OUT YOUR DOOR PEEPHOLE.

HOW TO DRAW CHIBI

CHIBI PLANES

THIS PLANE IS JUST A COMPRESSED
VERSION OF THE REAL THING.

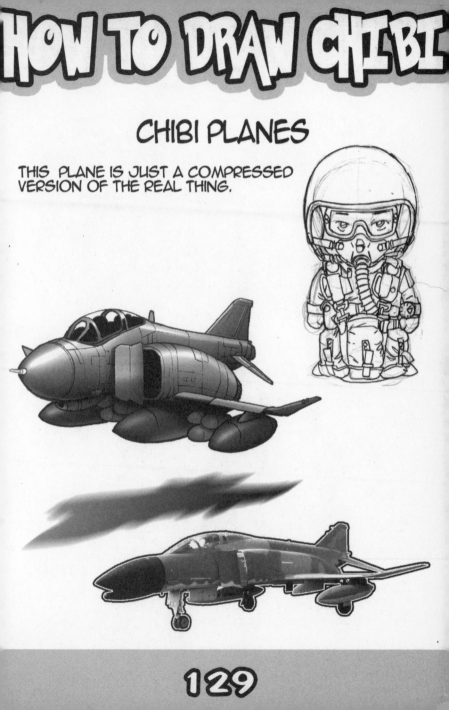

HOW TO DRAW CHIBI

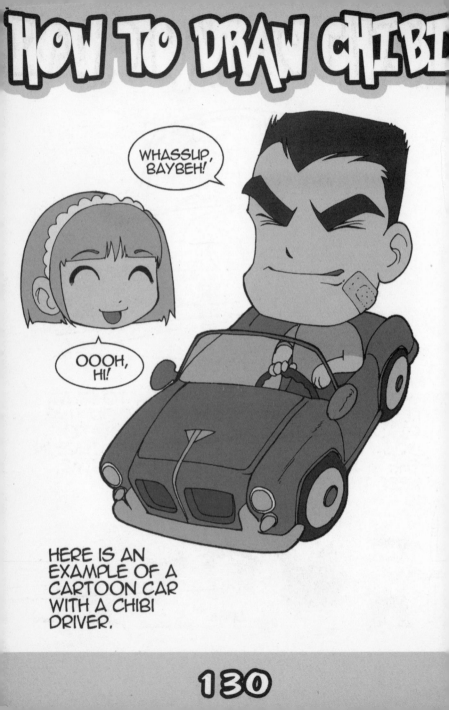

WHASSUP, BAYBEH!'

OOOH, HI!

HERE IS AN EXAMPLE OF A CARTOON CAR WITH A CHIBI DRIVER.

HOW TO DRAW CHIBI

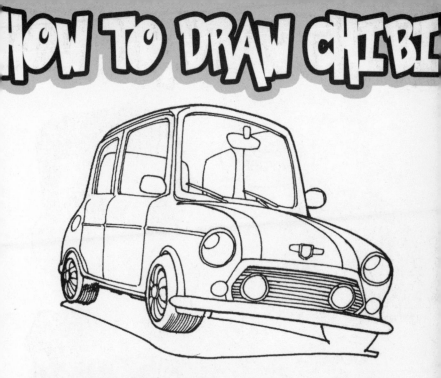

WELL, THAT WRAPS UP OUR HOW TO DRAW LESSON. WE HOPE YOU HAD A GOOD TIME READING AND LEARNING ABOUT HOW TO DRAW CHIBI! ENJOY THE BONUS FEATURE IN THE NEXT CHAPTER, AND UNTIL NEXT TIME, KEEP THOSE PENCILS BUSY!

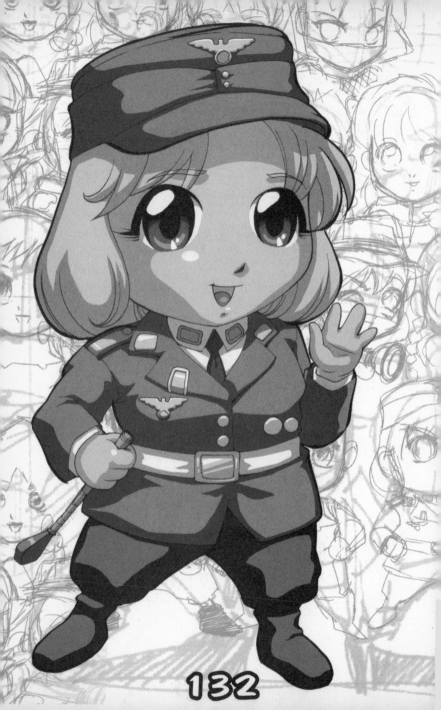

132

CHAPTER 7

TIPS FOR GETTING INTO COMICS

SPECIAL BONUS FEATURE ON HOW TO GET INTO THE COMICS BUSINESS

Special section on
How to Break into Comics

HOW TO DRAW CHIBI

SO YOU WANT TO BE A COMIC BOOK SUPERSTAR? AH, DON'T WE ALL! BUT FIRST THINGS FIRST! "HOW DO I BREAK IN TO THIS GLORIOUS FIELD?" WELL, IT ALL STARTS WITH THE SUBMISSION PROCESS! A PATH TO GLORY THAT COULD ONE DAY MAKE YOU A LEGEND IN YOUR OWN TIME! SO COME ALONG AS WE CHASE THE DREAM!

HOW TO DRAW CHIBI

PART 1:
SUBMITTING DIRECTLY TO A COMIC COMPANY

STEP 1:
PICK YOUR PROFESSION!
WHERE DO YOUR TALENTS LIE? DO YOU WANT TO BE A WRITER, PENCILER, INKER, LETTERER, ETC., OR ALL OF THE ABOVE? PICK YOUR STRENGTHS AND ROLL WITH THEM!

STEP 2:
WHAT'LL IT BE?
HOW DO YOU WANT TO WORK FOR A COMPANY...
A. WORK FOR HIRE:
WORKING ON A PARTICULAR COMPANY'S TITLES AND CHARACTERS
OR

B. CREATOR FOR HIRE:
WORKING ON YOUR OWN CREATION FOR A
PARTICULAR COMPANY

EACH HAS ITS PROS AND CONS:
WORK FOR HIRE-
PRO: STEADY PAY IF YOU'RE CONTRACTED
FOR A BOOK.
CON: YOU DON'T OWN THE RIGHTS TO THE
STORIES OR CHARACTERS.
CREATOR FOR HIRE-
PRO: YOU OWN THE PROPERTY! ALL THE CHARACTERS,
STORIES, AND RIGHTS TO MARKET THEM, ETC.
CON: UNRELIABLE AND IRREGULAR PAY, UNLESS
YOU'VE ESTABLISHED YOURSELF AS HAVING
A RELIABLE FAN BASE.

HOW TO DRAW CHIBI

STEP 2:
REFINE THAT PORTFOLIO!

ONCE YOU'RE DONE FIGURING OUT WHAT IT IS YOU WANT TO FOCUS ON, START A PORTFOLIO! A PORTFOLIO IS A SAMPLE OF YOUR WORK THAT SHOWCASES YOUR TALENT TO THE PEOPLE THAT MAY POTENTIALLY GIVE YOU WORK. SO MAKE SURE YOU INCLUDE ONLY THE WORK THAT YOU FEEL IS THE BEST REPRESENTATION OF YOUR TALENT. IT IS ALSO A GOOD IDEA TO INCLUDE ANY PROFESSIONALLY PUBLISHED WORK IN YOUR PORTFOLIO; THIS SHOWS THAT YOU ARE FAMILIAR WITH WORKING WITH A PUBLISHER AND THAT YOU HAVE WORKED PROFESSIONALLY.

DO:

1) INCLUDE YOUR BEST, MOST UP-TO-DATE WORK.

2) SHOW SAMPLES OF SEQUENTIAL PAGES.

THINGS TO KNOW ABOUT ASSEMBLING YOUR PORTFOLIO:

1. USE ONLY YOUR BEST PIECES.

2. IF YOU HAVE A LARGE VARIETY OF WORK, MAKE SURE YOU ORGANIZE IT BASED UPON A CERTAIN THEME, SUCH AS KEEPING ALL YOUR SEQUENTIAL COMIC BOOK PAGE SAMPLES TOGETHER.

3. INCLUDE PUBLISHED SAMPLES OF YOUR WORK, IF ANY.

NOTE!
SUBMITTING ART:
BEFORE YOU SUBMIT ART TO A PARTICULAR PUBLISHER, IT IS WISE TO STUDY WHAT THE PUBLISHER PUBLISHES! I WOULDN'T RECOMMEND SHOWING MOSTLY SUPERHERO ART IF THAT PUBLISHER DOESN'T PUBLISH SUPERHERO COMICS. WITH THAT IN MIND, GEAR YOUR SUBMISSION TOWARD THE TYPICAL GENRE OF TITLES THAT COMPANY PUBLISHES.

PIN-UPS VS. SEQUENTIAL PAGES:
COMIC COMPANIES ARE IN THE BUSINESS OF TELLING STORIES FROM PANEL TO PANEL, SO ANY ASPIRING COMIC ILLUSTRATOR SHOULD FILL UP HIS PORTFOLIO WITH PAGES OF SEQUENTIAL ART. IF IT'S FULL OF PIN-UPS, IT DOESN'T SHOW AN EDITOR THAT YOU CAN TELL A SEQUENTIAL STORY.

HOWEVER, IF YOU CAN DRAW PANEL-TO-PANEL PAGES WELL, AN EDITOR WILL MOST CERTAINLY BELIEVE YOU CAN DRAW A GOOD PIN-UP OR COVER. IF YOU ABSOLUTELY HAVE TO SHOW HOW GREAT YOU ARE WITH PIN-UPS AND WANT TO INCLUDE THEM WITH A SUBMISSION OR A PORTFOLIO, MAKE SURE THE SEQUENTIAL PAGES FAR OUTNUMBER THE PIN-UPS.

DON'T:

1) SHOW OLD DRAWINGS OR SKETCHES FROM 5 YEARS AGO. YOUR SAMPLES SHOULD REFLECT YOUR CURRENT SKILL LEVEL.

2) EVER SAY YOU HAD TO RUSH YOUR SAMPLES.

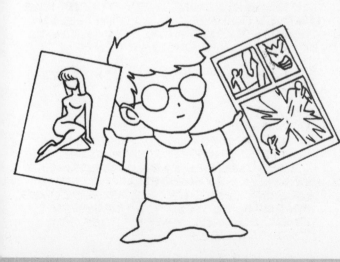

STEP 3
SUBMIT!

LET THE PUBLISHER SEE YOUR GUSTO!
IT'S TIME TO LET A COMPANY SEE YOUR SUBMISSION AND MARVEL AT YOUR CREATIVE POTENTIAL. THE FIRST THING TO DO IS INQUIRE ABOUT A PARTICULAR COMPANY'S ALL-IMPORTANT "SUBMISSION GUIDE-LINES"! THESE TELL YOU EXACTLY THE TYPE OF WORK THEY'RE LOOKING FOR, HOW MANY EXAMPLES THEY'D LIKE TO SEE, AND MOST IMPORTANTLY, TO WHOM YOU SHOULD SEND THEM!

START BY WRITING TO A COMPANY AND ASKING THEM FOR A COPY OF THEIR SUBMISSION GUIDELINES. MOST COMPANIES' ADDRESSES CAN BE FOUND IN THEIR BOOKS. LOOK IN ANY PARTICULAR BOOK'S COPYRIGHT INFORMATION.

REMEMBER:

SHOWING YOUR PORTFOLIO IS LIKE GOING TO A JOB INTERVIEW. PUT YOUR BEST FOOT FORWARD AND BE COURTEOUS IN YOUR LETTER.

STUDY GOOD COVER LETTER-WRITING HABITS.

NOTE: IN THIS "AGE OF THE INTERNET," MANY COMPANIES POST THEIR CONTACT INFO AND SUBMISSION GUIDELINES ON THEIR WEBSITES, SO CHECK!
GOOD LUCK!